LANDSCAPE

PHOTOGRAPHS OF TIME AND PLACE

Ferdinand Protzman

LANDSCAPE

PHOTOGRAPHS OF TIME AND PLACE

Ferdinand Protzman

NATIONAL GEOGRAPHIC

Washington, D.C.

CONTENTS

CHRIS CHAPMAN, "JAMES RAVILIOUS PHOTOGRAPHING IN WISTMAN'S WOOD, DARTMOOR," 1997

PREVIOUS PAGE: MANUEL SENDÓN, "CENTRE FOR DRIVERS. PSYCHOLOGICAL EXAMINATION—VIGO," SPAIN, 1991

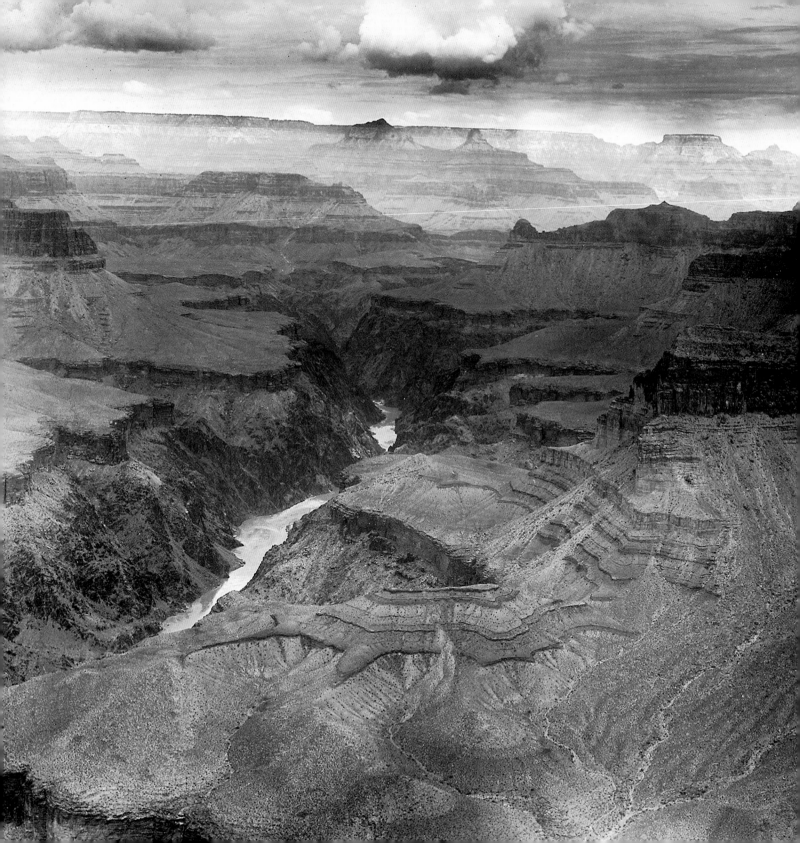

N. H. DARTON, "GRAND CANYON:
VIEW TO THE EASTWARD FROM GERTRUDE POINT," 1913

LANDSCAPE PHOTOGRAPHY IN THE PAINTERLY TRADITION:
AN ELEVATED VIEWPOINT LOOKING ONTO A CORNUCOPIA
OF FORMS, TEXTURES, SHADOWS, AND A SUNLIT HORIZON

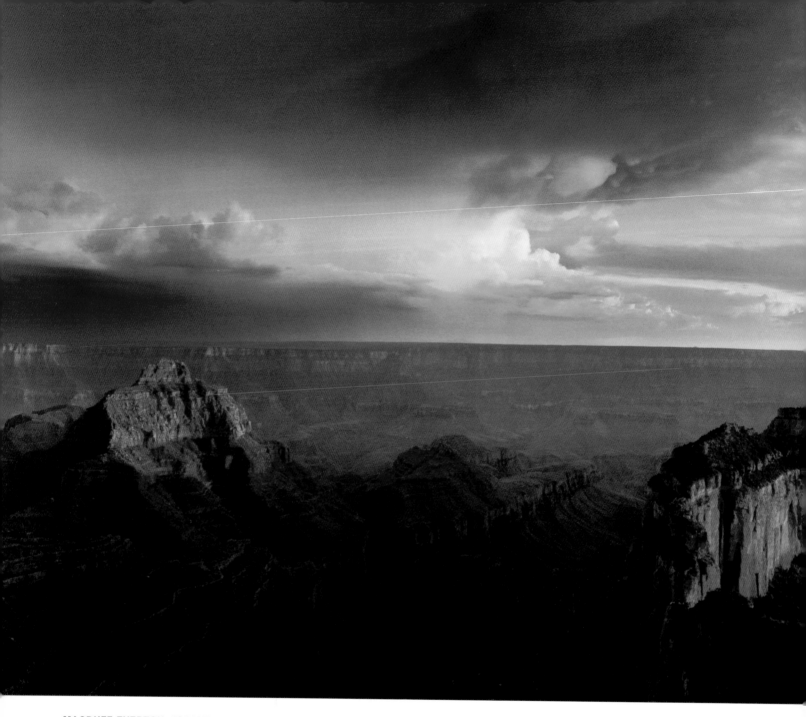

MACDUFF EVERTON: "GRAND CANYON, CAPE ROYAL, NORTH RIM," 1996

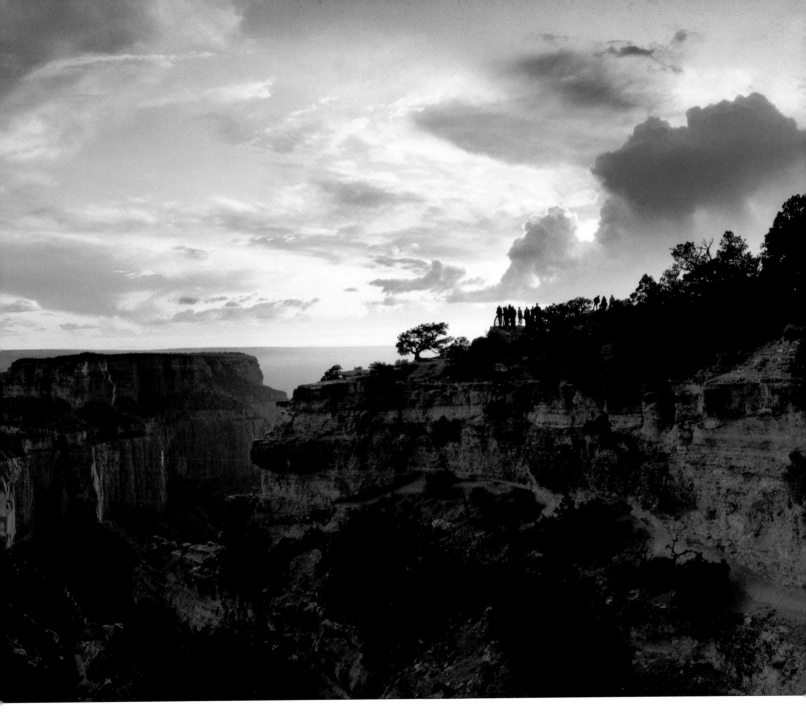

EVERTON'S SPECTACULAR SUNSET EVOKES THE GRANDIOSITY OF ALBERT BIERSTADT'S
PAINTINGS OF THE AMERICAN WEST, WHILE SUBTLY EXPOSING THE MYTH OF PRISTINE NATURE
BY INCLUDING TOURISTS, SILHOUETTED ON THE RIDGE, WATCHING THE LIGHT SHOW.

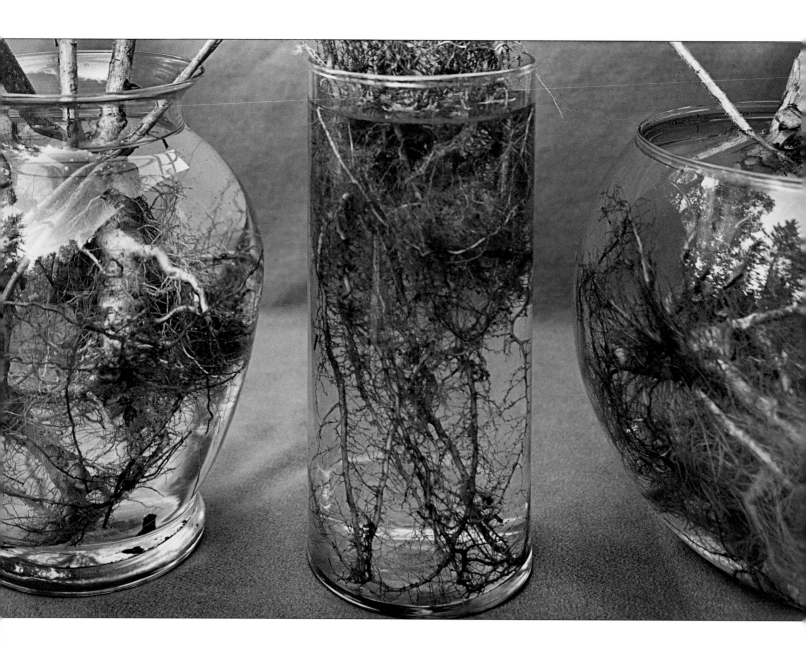

THE SUPREME TEST

WHILE LIVING IN GERMANY IN THE 1990S, I RETURNED TO MY HOMETOWN IN THE UNITED STATES TO SPEND Christmas with my family. I couldn't wait to get back to Decatur, a small industrial city on the Illinois prairie. Before departing, I bored friends in Bonn with stories of vast horizons, fresh winds, and oceanic blue sky punctuated by spectacular sunrises and sunsets. My telling transformed a place known as the "Soybean Capital of the World" into arcadia.

The main components of my tales—the light, the colors, the space—were an idealized landscape, a patchwork pieced together from memories. I'd been living in Europe for years, constantly traveling for work, and this imaginary arcadia reinforced my sense of self and gave me a basis for understanding the world. I knew my unspoiled prairie home was a myth, but I still planned to photograph it.

That proved difficult. A front, wet and gray as fresh cement, was parked over the Midwest when I arrived. Finally, after a Christmas snowstorm, the sky cleared, revealing the sweep of flat land glistening under a cerulean sky.

Late one afternoon, my sister and I went walking in a nature center by the Sangamon River. At the end of our hike we came to an expanse of prairie. The sun was setting, joining heaven and Earth in a cascade of

PAUL CAPONIGRO, "PLANT ROOTS, CUSHING, MAINE," 2001
A TONE POEM OF ROOTS AND REFLECTIONS BY A MASTER PHOTOGRAPHER. CAPONIGRO'S PERSONAL VISION ENCAPSULATES THE SWEEP OF LANDSCAPE PHOTOGRAPHY FROM WILLIAM HENRY FOX TALBOT'S ERA TO CONTEMPORARY ART'S CONCEPTUAL AND MINIMAL EDGE.

orange, purple, and blue fire. Seizing the moment, I shot the remaining frames in my camera.

When I got the film developed back in Bonn, the sunsets glowed. These weren't just snapshots, I decided, but art, emanating the essence of my arcadia. I took the pictures to work and proudly showed them off to a German colleague.

"Lovely colors," she said. "Too bad they're so out of focus."

She was right. The colors, I realized, were also off. "You get nice sunsets on the seaside, too," she added, laughing at my stunned expression.

I had to laugh along with her. Back in the envelope went the fuzzy, too-red pictures except for one I tacked to my bulletin board as a reminder that photographing the landscape is a triangulation involving three mysterious variables: time, place, and people.

My experience was not unique. "Landscape photography is the supreme test of the photographer," Ansel Adams wrote, "and often the supreme disappointment." Whether amateur or professional, artist or tourist, anyone photographing or otherwise depicting the landscape faces the difficult task of turning what they see in the world into a picture. How can any image rival the experience of being outdoors: the views, the boundless space, the air, the colors, the ever changing light, the geography, the flora and fauna, and the sensations and the feelings these things evoke?

Yet, for centuries, people have tried. The subject, one of the oldest in visual art, predates the word, which derives from the Dutch term "landschap" and was introduced as a technical term for painters. Landscapes first appeared in Western culture as murals adorning the homes and public buildings of ancient Rome. The landscape tradition is even older in Chinese art. From these origins, landscapes, in various media, have become the world's most popular form of art.

That popularity is due in large measure to photography. The earliest photograph still in existence, Joseph-Nicéphore Niepce's 1827 view taken from an upper window of his home in Saint Loup de Varenne, France, shows farm buildings, trees, and a distant horizon—in sum, a landscape. William Henry Fox Talbot, whose discovery, announced in 1839, of the negative-to-positive paper process made multiple reproductions of a single image possible—thus establishing the photographic process still used today—early on employed his camera and refined aesthetic sensibility to produce a number of lovely pictures of the woods, fields, and waters around his home at Lacock Abbey Estate in England.

Talbot was a brilliant polymath, and his photographs were informed by his knowledge of art history, particularly European painting, drawing, and printmaking. In style and composition, his landscapes reflect the aesthetic tradition established by Europe's greatest landscape

artists, such as Albrecht Altdorfer, Jacob van Ruisdael, John Constable, Joseph Mallord William Turner, and Jean-Baptiste-Camille Corot. That aesthetic would hold sway over photographic landscapes until the 1960s, and remains a major influence.

Despite such illustrious antecedents, this union of universally appealing subject and accessible technology capable of reproducing images ad infinitum was not welcomed with open arms by 19th-century artists and critics. In 1859 Charles Baudelaire greeted the French Society of Photography's first exhibition in the Palace of the Champs Elysées, a show coinciding with the famous painting Salon, by denigrating the new medium. In *The Mirror of Art,* he wrote that photography's appropriate uses should be limited to tourist snapshots, copying books and old manuscripts for posterity, and archaeological documentation. "But if it be allowed to encroach upon the domain of the impalpable and the imaginary, upon anything whose value depends solely upon the addition of something of a man's soul, then it will be so much the worse for us!"

The notion that photography's mechanical nature proscribes it from being art was a blatant attempt to preserve the intellectual and commercial high ground for painters and painting, and it succeeded for over a century. Opponents of photography flaunted its limitations; compared with paintings, photos were tiny, drab, flat,

impermanent, and fragile. The technology was dismissed as too easy and too accessible, involving neither skill nor thought. Although this battle against photography as art is specious, akin to banning an art-making tool such as oil paint because it produced different results from egg tempera, it drones on. In the meantime, photography has become the most prevalent medium in contemporary art.

Photography's rise to prominence was caused by a confluence of cultural, generational, and technological factors. Younger artists, who had grown up seeing photographs, movies, and television, had no problem questioning the supposed objectivity of photographic representation and embracing photography to make highly personal, conceptual art. That embrace became a bear hug as the evolution of photographic technology enabled them to create pictures rivaling the color, size, and depth of field of paintings.

The acceptance of photography as a valid art form and the technological advances in cameras, film, lighting, and printing helped broaden the definition of photography to include film and video stills and, later on, digital works. Even sculptors and painters began making "photo-based" works in which they conceived the image but assistants handled the camera.

In landscape photography, the medium's new status and capabilities soon manifested themselves in bigger, bolder

color photographs examining the complex relationship between humans and the natural world. Nontraditional landscape subjects appeared, such as urban sprawl, industrial pollution, and garbage dumps. Photographers became less interested in precisely depicting landscape than in exploring their emotional responses to it.

Photography's elevated importance has been touted as a paradigm shift by art theoreticians, meaning a revolutionary break with past theory and practice. Looking at old photographs, however, reveals no radical break separating artists such as John Beasley Greene, Alfred Stieglitz, and Eliot Porter from contemporary photographers. In landscape, at least, the personal, conceptual, and overtly artistic approaches that will be explored in this book can be seen from the first photographs onward.

Talbot clearly understood his invention's potential for art, writing: "I do not profess to have perfected an art but to have commenced one, the limits of which it is not possible at present exactly to ascertain. I only claim to have based this art on a secure foundation.…It will be a far more skilled hand than mine to rear the superstructure."

Photographers immediately began building upon Talbot's foundation, and their work continues. Their art, however, comes not just from technical proficiency but from keen eyes and minds. Every photograph is manipulated by the person taking the picture. That manipulation, physical or mental, is most evident in landscape photos, where the artist selects and frames a piece of the natural world. Since all human beings view life from the subjective shell of the self, this selection is subjective.

John Beasley Greene's "The Nile," for example, shows a grove of trees seen from across the stream described by French writer Gustave Flaubert as "flat as a river of steel." The grove is just a smudge above the black line of the bank. Low hills in the distance seem to dissolve in the sun. These simple elements coalesce into a lambent image of heaven, Earth, and time flowing from the cradle of civilization. Chosen by Greene's eye, developed by his hand, imbued with his knowledge and aesthetic, it is the quintessence of minimalist power more than a century before minimalism was conceived.

Gustave Le Gray, Greene's mentor, was more overtly manipulative, using two negatives, one for the sea and another for the sky, to create his theatrical seascape "The Great Wave, Sête," around 1856, long before digital manipulation was causing furor.

It took but one negative for Roger Fenton, an Englishman born in 1816, to create "Valley of the Shadow of Death" in 1855, while on assignment photographing the Crimean War. The first great sociopolitical landscape photograph, it remains one of the most powerful antiwar images, devoid of human presence, awash in humanity.

Documenting the vestiges of Native-American culture after the ravages of white settlement was Roland Reed's concern. His photo of two Navajo looking at the Anasazi ruins in Canyon de Chelly is stagy and voyeuristic, but packs visual and emotional force. By contrast, Adams's epic picture of Boulder Dam seems to extol the virtues of Western development. But its positivist sheen is subtly corroded by the dam's outflow, swirling like a toilet.

Other photographers, such as Stieglitz, concentrated on the medium's aesthetic possibilities. His "Sketching in the Bois" is a tone poem praising sublime nature, while "From the Back-Window—291" is an urban nocturne that only a camera and black-and-white film and Stieglitz could play.

Industrial forms reduced to their essence attracted Charles Sheeler's eye to the storage bins at the Ford Motor Company's mammoth River Rouge plant. A single form, the stone cross, functions as a memento mori in Walker Evans's "Bethlehem Graveyard and Steel Mill," a complex, layered study of the ambiguous symbiosis of people, industry, and culture.

The constant search for new ways of seeing the natural world is another thread tying current landscape photography to its past. Minor White and Eliot Porter saw something fresh and lyrical in the California surf and a New Hampshire stream, scenes countless artists had already depicted. Porter also demonstrated how color photography, by giving light and space a full palette of colors, could compete with painting.

Photography's modernist purists still despise color. To them, Ansel Adams's photo of the Grand Teton and Snake River epitomizes what landscape photography should ever be: crisp images and clean textures limned in shades of gray, a heroic subject lifting the viewer's eyes toward heaven in the manner of Baroque church architecture.

Fortunately, one person's dogma is another's open question. More than 150 years after photography was born, photographers from around the world are still expanding the limits of the art Talbot commenced. Their pictures have changed the way we see and interact with the landscape, even as the technological explosion that began with the industrial revolution has altered the face of the Earth and our relationship to it.

For artists such as Edward Burtynsky, those changes are the stuff of art. Burtynsky makes landscape pictures as beautiful, crisp, and clear as those of any of his artistic forebears but with an ambiguous spiritual resonance reflecting our age. Since time, place, and people are constantly changing, he seems to ask, who is to say that a neon-orange river polluted by nickel tailings doesn't flow straight from God?

JOHN BEASLEY GREENE, "THE NILE," 1853-54

GUSTAVE LE GRAY, "THE GREAT WAVE, SÊTE, CIRCA 1856

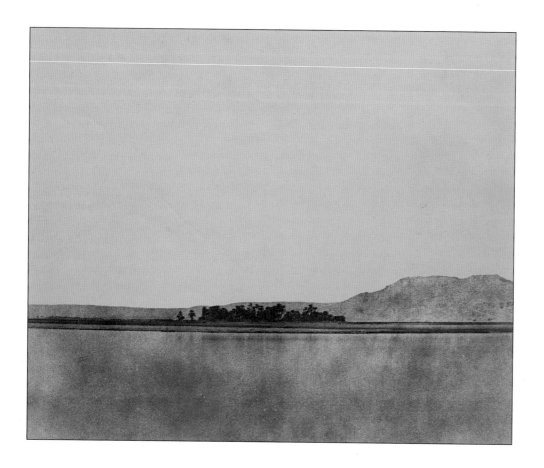

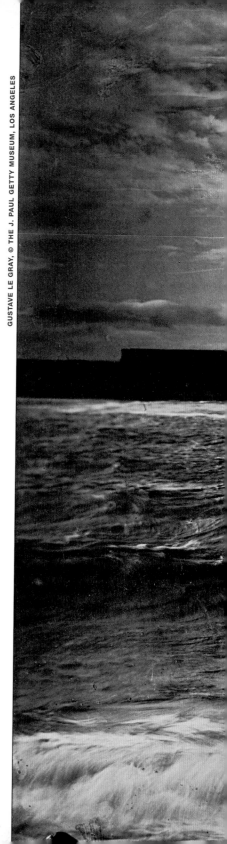

GREENE WAS BARELY 20 YEARS OLD WHEN HE WENT TO EGYPT AND NUBIA AND CREATED THIS AUSTERELY BEAUTIFUL PHOTOGRAPH OF THE NILE. LE GRAY WAS A SKILLED DRAFTSMAN AND PAINTER WHOSE BRILLIANT SEASCAPES REFLECT HIS TRAINING, VISUAL IMAGINATION, AND TECHNICAL INNOVATIONS, SUCH AS USING ONE NEGATIVE FOR THE SEA, ANOTHER FOR THE SKY.

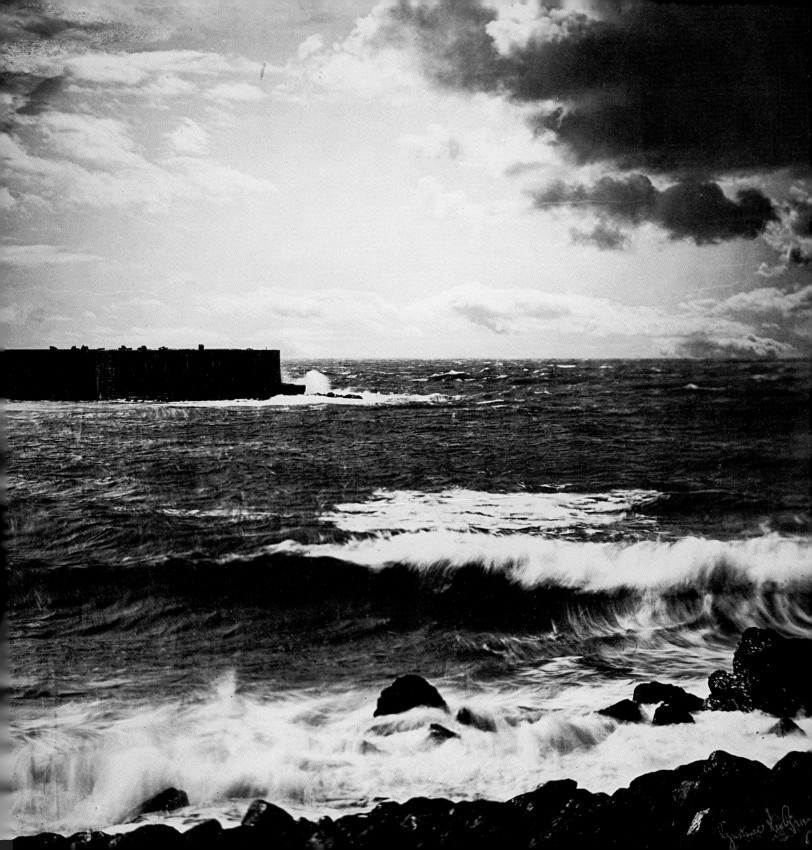

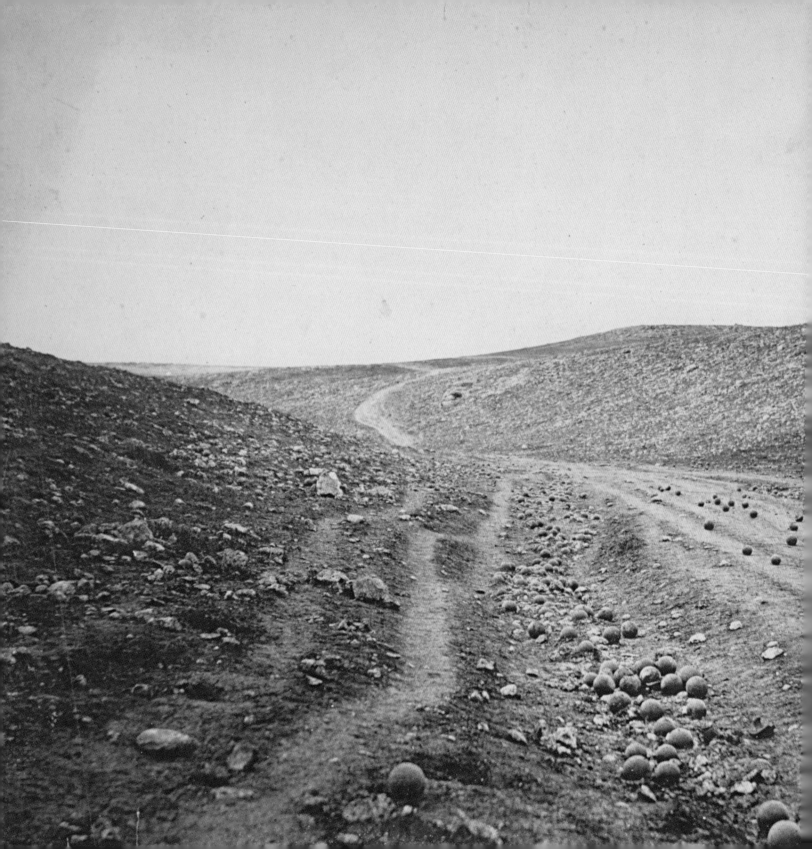

FENTON, WHO BRIEFLY PURSUED A CAREER AS A PAINTER IN PARIS, COMPOSED
AN UNPAINTERLY LANDSCAPE OF ELOQUENT SIMPLICITY. THE BARREN VALLEY IS
NOT THE SITE OF THE LIGHT BRIGADE'S DISASTROUS CHARGE, BUT ITS GROUND,
POCKMARKED BY SHOT AND SHELL, CHURNED BY HOOVES, AND LITTERED WITH
CANNONBALLS, KEENS FOR THOSE SLAUGHTERED IN A SENSELESS WAR.

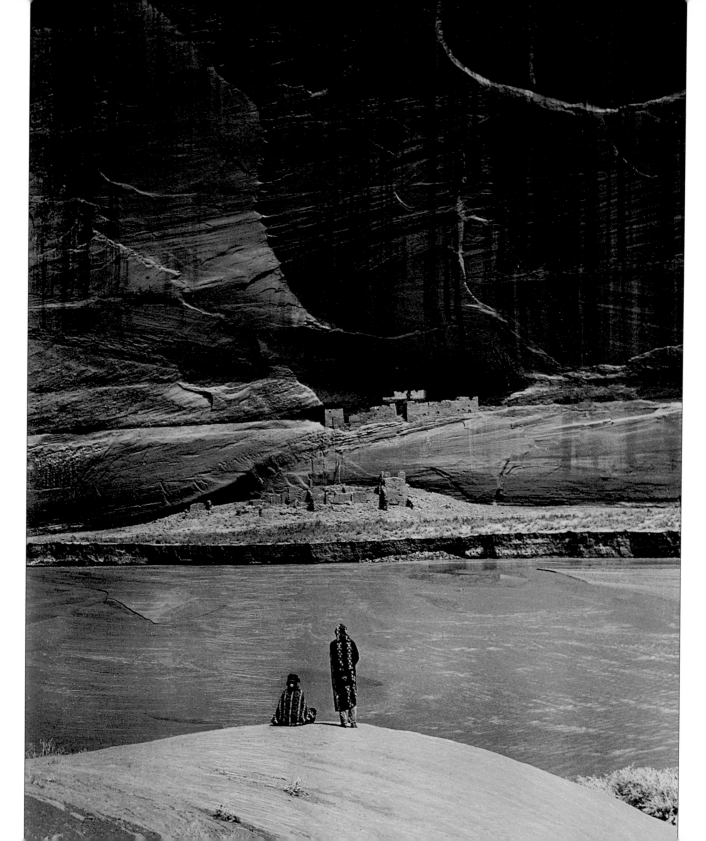

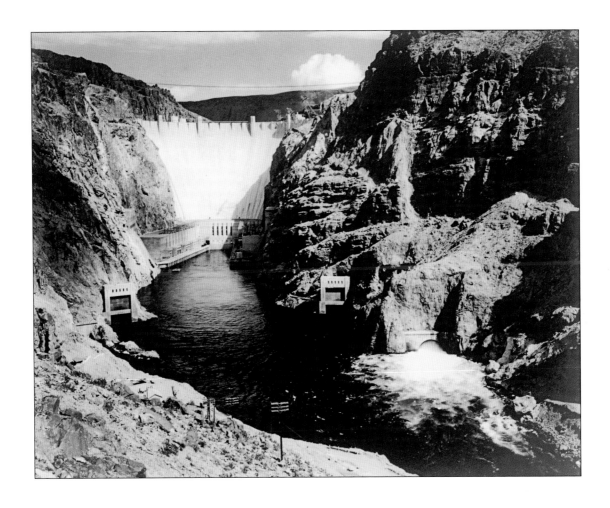

BY PUTTING TWO NAVAJO IN HIS PICTURE, REED TURNED A TOURIST MOTIF INTO A METAPHOR FOR THE DEVASTATION OF
THE ANCIENT NATIVE-AMERICAN TRIBES AND CULTURES. ADAMS'S PHOTO, COMMISSIONED BY THE U.S. GOVERNMENT,
PUTS THE DAM IN A BRIGHT, POSITIVIST LIGHT, AS IF HYDROELECTRIC POWER AND WILDERNESS WERE NATURAL PARTNERS.

ALFRED STIEGLITZ, "SKETCHING IN THE BOIS," 1894

ALFRED STIEGLITZ "FROM THE BACK WINDOW—291," 1915

ALFRED STIEGLITZ, © NATIONAL GALLERY OF ART, WASHINGTON D.C., ALFRED STIEGLITZ COLLECTION

STIEGLITZ'S ARTISTIC STYLE EVOLVED, BUT NEVER ESCAPED PAINTING'S AESTHETICS. ON HIS HONEYMOON IN EUROPE, HE CREATED A POETIC LANDSCAPE CELEBRATING SUBLIME NATURE. TWENTY YEARS LATER, HIS VISION OF NOCTURNAL NEW YORK WAS INFLUENCED BY CUBISM AND THE BELIEF THAT THE FUNCTION OF PHOTOGRAPHY WAS TO REVEAL THE OBJECTIVE REALITY OF FORM RATHER THAN PROVIDE AESTHETIC PLEASURE. NONETHELESS, IT'S GORGEOUS AND LYRICAL. *PLUS ÇA CHANGE.*

CHARLES SHEELER, "STORAGE BINS AT BOAT SLIP, FORD MOTOR COMPANY, ROUGE PLANT, DEARBORN, MICHIGAN, 1927"
WALKER EVANS, "BETHLEHEM GRAVEYARD AND STEEL MILL," BETHLEHEM, PENNSYLVANIA, 1935

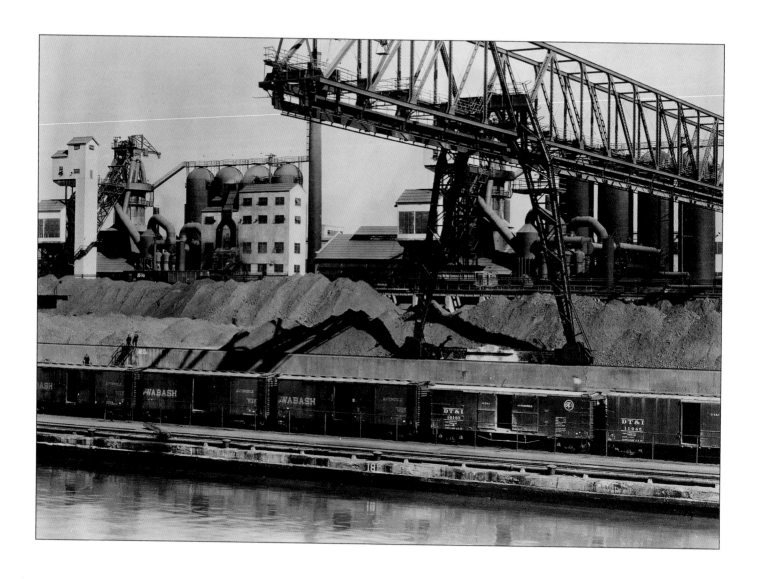

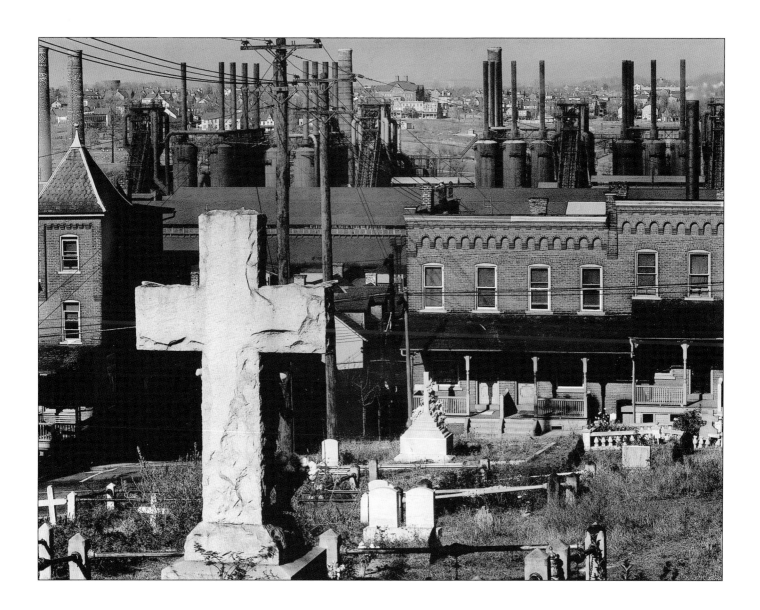

A PRECISIONIST PAINTER, SHEELER DEPICTED FORD'S RIVER ROUGE PLANT AS AMERICAN INDUSTRIAL SPLENDOR: EXACT GEOMETRIC FORMS, NO HUMAN PRESENCE, NO SOCIAL COMMENTARY. BY CONTRAST, EVANS'S PHOTO USES MAN-MADE FORMS TO SHOW THE CYCLE OF LIFE IN A HARDSCRABBLE STEEL TOWN. THE CROSS IS A METAPHOR FOR SUFFERING AND DEATH, BUT ALSO FOR FAITH, HOPE, AND REDEMPTION.

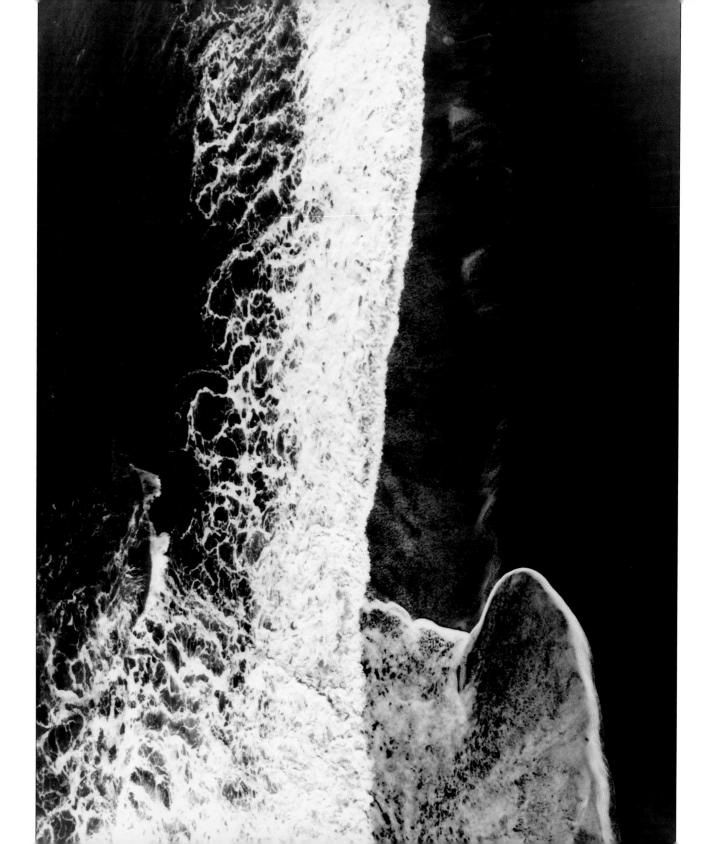

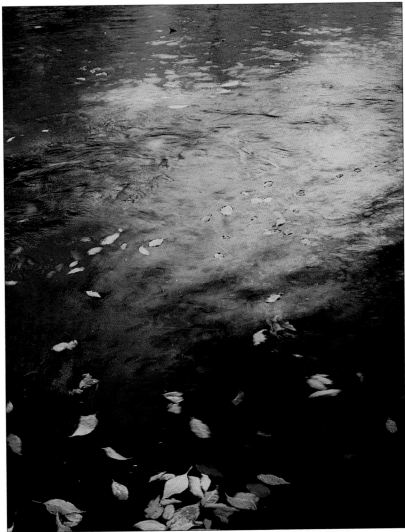

ELIOT PORTER, © 1990, AMON CARTER MUSEUM, FORT WORTH, TEXAS, GIFT OF THE ARTIST

WHITE AND PORTER WERE PIONEERING PHOTOGRAPHERS, USING THE CAMERA'S PORTABILITY TO SEE THE WORLD FROM FRESH VIEWPOINTS. WHITE'S WORK EMPHASIZES FORM, MOVEMENT, AND TONALITY. PORTER WAS ONE OF THE FIRST ARTISTS TO USE COLOR FILM. HIS BEAUTIFUL, IMPRESSIONISTIC PICTURES HELPED LEGITIMIZE COLOR PHOTOGRAPHY AS AN ART FORM.

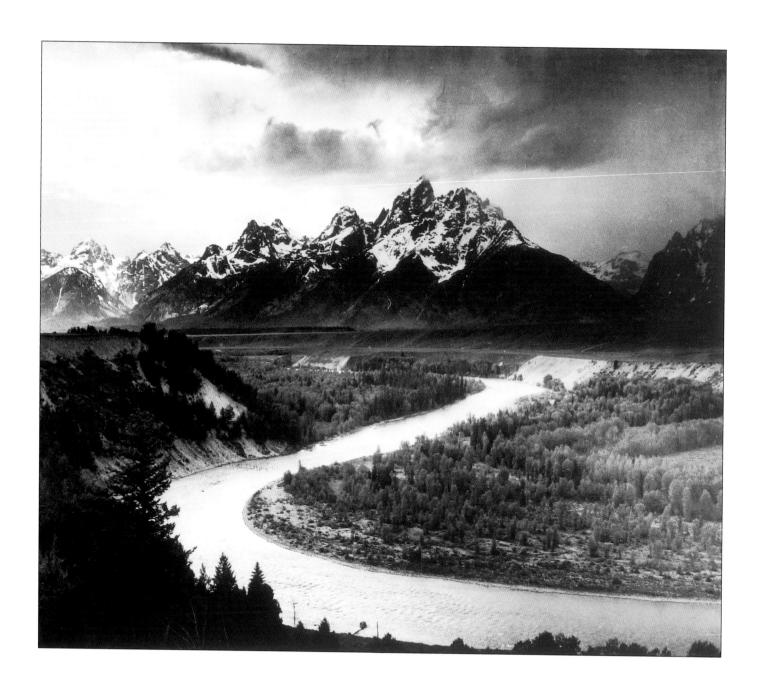

ANSEL ADAMS, "THE TETONS—SNAKE RIVER," WYOMING, 1942
EDWARD BURTYNSKY, "NICKEL TAILINGS #39, SUDBURY, ONTARIO" 1996

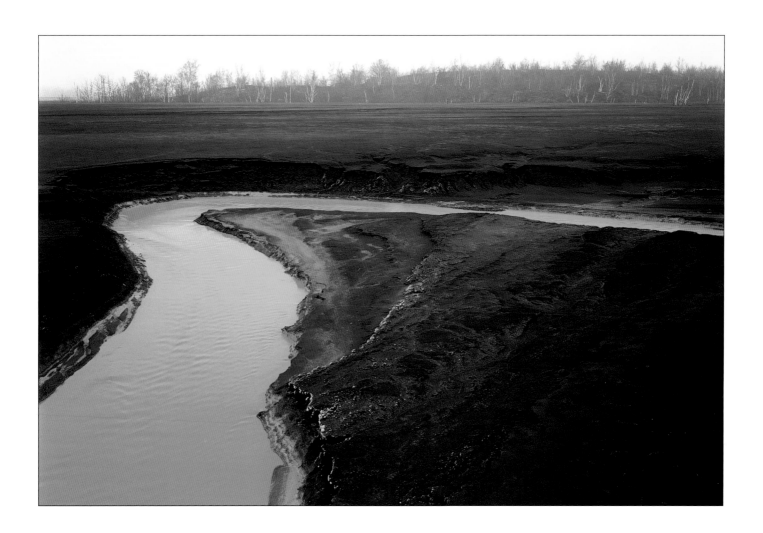

THE PICTURESQUE, WITH ITS SPIRITUAL HISTRIONICS, WAS A KEY ELEMENT OF 19TH-CENTURY EUROPEAN LANDSCAPE PAINTING AND ANSEL ADAMS'S WORK. EDWARD BURTYNSKY'S MAIN THEME IS NATURE TRANSFORMED THROUGH INDUSTRY. "I SET COURSE TO INTERSECT WITH A CONTEMPORARY VIEW OF THE GREAT AGES OF MAN; FROM STONE, TO MINERALS, OIL, TRANSPORTATION, AND SILICON," HE SAYS. BURTYNSKY SEARCHES FOR SUBJECTS "RICH IN DETAIL AND SCALE, YET OPEN IN THEIR MEANING."

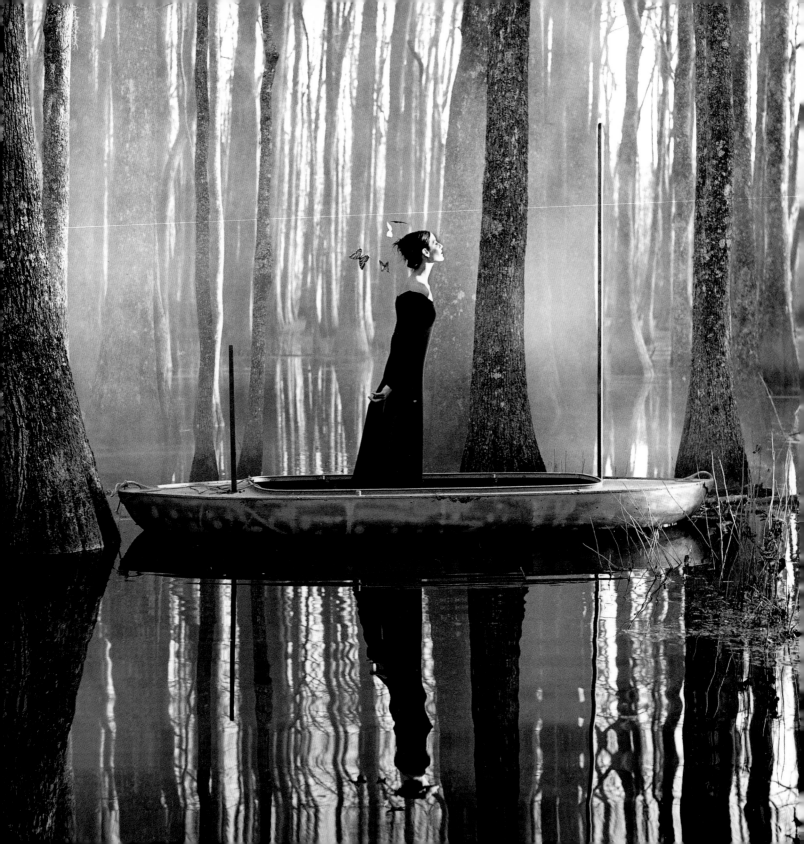

LANDSCAPE BEHIND THE SCENES

THE MELTING TOGETHER OF MEDIA IN THE DIGITAL ERA HAS BEEN A HOT TOPIC IN ART CIRCLES AND academe since the mid-1990s, although it actually began three decades before when artists discovered photography was a great tool for making conceptually based work. The resulting photographs helped expand the definition of landscape to include everything you observe when you go outside. Significant as those developments were, they rank as more evolutionary than revolutionary. Where landscape is concerned, the marriage of art and ideas occurred shortly after the Dark Ages. The wedding was in Italy. The public was invited.

After disappearing in the Dark Ages, landscapes reemerged as art in the early Renaissance as backgrounds behind the central subjects on altarpieces and in portraits of the Italian nobility, replacing the then-standard, gold-leaf backgrounds adopted from Byzantine art. This change was revolutionary; a significant portion of the picture plane went from being flat, abstract, and static to realistic, natural, and dynamic, the outdoors brought indoors. The new paintings demonstrated landscape's evocative power and its unique ability to alter the subject's meaning.

In altarpieces painted by Piero della Francesca and others, scenes of Christ's life and death no longer played out in the heat and dust of ancient Judea and Galilee, but amid the more temperate hills and valleys of

RODNEY SMITH, "DANIELLE IN BOAT, BEAUFORT SC," 1996
DEEPLY ATMOSPHERIC, ENCHANTING, AND A BIT DISTURBING, SMITH PRESENTS FASHION AS A MYSTERIOUS AESTHETIC GARMENT MADE FROM STYLE, AMBIANCE, AND ATTITUDE. ALTHOUGH THE COMPOSITION IS OVERWROUGHT AND SELF-CONSCIOUS, THE SWAMP'S EVOCATIVE POWER TURNS THIS FROM PRISSY FLUFF INTO HIGH ART.

northern Italy. Jesus was transformed from a Middle Eastern Jewish prophet and part-time carpenter into an Italian Renaissance man. The message to viewers was clear. Christ, his teachings, and his disciples were a vital, powerful presence in everyday life, not historical characters frozen in gold. This new approach made the Roman Catholic version of Christianity, replete with saints and miracles, more real and tangible to the populace, as if the line for loaves and fishes began just outside the church door and heaven was a piece of the Tuscan campagna. The latter notion is still current today, albeit as a tourist lure.

Painted background landscapes also exerted their power in the secular realm. In Piero's portraits of the Duke and Duchess of Urbino, painted around 1465, the waterways, fields, and fortifications, glimpsed far below and behind the noble sitters, let the world know this couple resides high in the natural and social order.

These landscapes' force came from combining art's physical presence and psychological effects with something primal, universal, immediate, and virtually limitless: the physical world. Viewers didn't need to be literate or intelligent to find something in the depicted landscape—beauty, refuge, recreation, divinity, eternity, or danger and evil—relating to their lives.

For the artists, landscape's broad appeal and metaphorical richness provided manifold creative possibilities. Perspective, form, color, and light could be mixed and matched to create a broad range of imagery and effects. The combination of physical and psychological qualities allowed artists to use landscape's power to tell viewers what to think about the subject in the picture's foreground. This made art subtler, more subliminal, and far more potent.

Centuries later, when photography and photomechanical reproduction came along, the number of artworks in general and landscapes as background in particular began multiplying exponentially. In the early 21st century, countless landscape photographs are seen every day by hundreds of millions of people, not in galleries or museums, but as background imagery in magazines and newspapers, on television and in films, as computer wallpaper, and adorning the walls of dental practices or government offices.

The sheer volume of landscapes lurking behind the subjects of photographs makes it easy to overlook their meaning-altering ability. Yet their power hasn't diminished, it's just serving different masters. Landscape backgrounds have become a ubiquitous sales tool, used to peddle the gamut of products, organizations, ideas, and beliefs. Secular multinational corporations now commission most of the pictures.

Because landscape is universal, its background magic works everywhere. The latest car models wind through

mountain scenery in Asia, Europe, or the Americas. Personal products and laundry detergents float in front of sunlit meadows. It almost makes one long for the gold-leaf era or at least the second coming of Gustav Klimt.

Like other photographs, landscapes have evolved in many societies into fetishes, picture-objects that are regarded with obsessive devotion and irrational reverence. In industrial societies, landscape backgrounds have become a kind of collective fetish as evidenced by their use in advertising. Almost every advertisement for a sport-utility vehicle shows the truck powering through rough, dramatically beautiful scenery. This background, with its connotations of uncrowded space, clean air, and living off the beaten track, can be yours if you just buy the vehicle.

In fact, most sport-utility owners never go off-road. Yet the images of nature are so powerful they simply overwhelm the ads' obvious contradiction; driving a vehicle with deep-tread tires and a pollution-spewing engine damages and degrades the environment. But thanks to the landscape background fetish, that unpleasant reality becomes moot.

From the background, landscape can even turn style to substance, as witness Rodney Smith's photograph "Danielle in Boat, Beaufort SC," a fashion shot that becomes art because of its setting in a swamp. The trees surround the model as she stands in a pirogue, face bathed in light, butterflies fluttering behind her head. Danielle seems balanced between two worlds, about to either ascend to the godhead or be attacked by a swamp creature. That dichotomy is reinforced by the dress's shape, which echoes the tree trunks. Reflected in the dark water, however, model and dress look like a charred stump. Sic semper fashion. This year's dress is next year's rag.

There's genuine substance in the late Luigi Ghirri's "Spezzano Castello, Sala delle vedute," which shows a castle's "room of views," with its unremarkable mural of houses on a hilltop, surrounded by another mural of mountain landscape. Although the paintings reference a tradition dating back to Studius, the Roman decorative painter from the first century B.C. believed to be the first to paint murals on interior walls, Ghirri's photograph is about the idea of viewing landscape. Exactly where the background ends and the subject begins is impossible to say in this delightful picture of pictures of landscapes.

Glossy landscape photos are a pillar of the tourism business. Yet, when we travel, landscape frequently becomes secondary. No contemporary photographer probes this contradiction more incisively or wittily than Martin Parr. In his photo of Switzerland's "Kleine Scheidegg" range, the mountains appear artificial and irrelevant to the couple examining scarves at the souvenir shop. There's an implied narrative in many of Parr's photos drawn from our common experience as tourists. In this case, the couple may return home and

tell friends and neighbors of the spectacular Alps. But the scarf is the real trophy of their tour.

When Manuel Sendón was invited in 1989 to participate in a landscape exhibition, he decided that instead of taking landscape photos, he would explore how society used such pictures. He found landscapes serving as backgrounds, enlivening offices, restaurants, and game rooms throughout southern Spain. The Manhattan skyline in "O Couto—Ourense," for example, is so clear and sharp it seems like a window onto the city. That illusion has long since worn off for the kids playing foosball in the fluorescent glow of a grubby, windowless game room.

Landscape backgrounds are a key element in Arthur Tress's "Fish Tank Sonata" series, a narrative about an unlucky fisherman who meets a spirit fish that takes him on an odyssey of ecological discovery and self-discovery. "In Quiet Glades," shot in Congress Park in Saratoga Springs, New York, has a sexual charge. The woman in the scene seems vulnerable, barely keeping her head above water. The man, not in imminent danger, seems unconcerned by his companion's plight. The pond and park's serenity counters the urgency of desire and viewers' alarm.

The couple in Yoshio Itagaki's "Honey Moon: Wedding #1" would be just another Japanese pair in traditional wedding garb were they not posing on the moon. The background of the photo, which looks like a 19th-century hand-colored print, was created by computer. It's an engaging, if more obviously surreal approach to the tourist experience than Martin Parr's. By referencing old photographs, Itagaki suggests the urge to take our picture in landscape is now hard-wired into human nature.

Painting, photography, and popular culture have turned the landscape of the western United States into a cliché used as a backdrop in everything from John Ford Westerns to cigarette commercials. Richard Prince and William Albert Allard both have made pictures of the West. Prince's "Untitled (Cowboy)" is, at first glance, classic cowboy stuff, a rider holding his lariat high as his horse leaps a stream. But the scene is fake. Were the steed any higher, a flight plan would be required. The background puts Prince's Pegasus in mythic territory. The artist lets our imaginations and cultural conditioning decide whether it's a commercial, a comedy, or a calling.

The cowpoke in Allard's "Cattle drive, Quarter Circle A Ranch, Nevada" also holds his lariat in the classic pose. Unlike Prince's picture, Allard's photograph is earnest. This is the real West, where a dwindling number of cowboys still ride herd. Allard's take differs markedly from Prince's, yet the landscape gives his cattle drive just as much mythical weight.

Computer manipulation comes to mind looking at Jim Sanborn's photograph of Shiprock in New Mexico.

That impression is false. Sanborn used a powerful projector to throw an Agnes Martin grid on Shiprock, turning that monument into a study of mass, volume, and time. Seen as a whole, the gridded rock seems more immense and weighty. Inside the individual squares, however, its surface is diminished, crumbly, and fragile. Because of the long exposure times, stars show up as white lines, time measured in the sky with geometric precision. The landscape becomes a kind of chalkboard on which Sanborn marks time and human passage.

John Divola, in his "Isolated Houses" series, looks at the western landscape from a conceptual viewpoint focused on aesthetic and social concerns. "On the simplest level, I am drawn to the vernacular character of the architecture (painted with a Home Depot palette) as well as the amazing visual character of these structures on this vast desert plain lit by an extraordinary light," he wrote in a statement. "However, at base, my primary interest is to create images which are iconographic of a desire. A desire to be "beyond," a desire to be alone—a sign of man on the landscape." Despite the classic western colors and vistas, there's little romance or mythic quality to these pictures, just the terrible beauty of life on society's fringe.

Isolation is also a central theme in Andrea Modica's "Treadwell, N.Y." series of photographs, which tells the story of a family with 14 children that is barely surviving on the impoverished margin of mainstream American life. Because Modica shoots with an 8" x 10" view camera and makes platinum prints, her pictures have a 19th-century look, making the subjects seem adrift in time, as well as life.

One of the central figures in the series is Barbara, an overweight child with the face of a dyspeptic angel. Modica posed Barbara in various settings. One of the most powerful images shows the child wrapped in an afghan, lying in a trash-strewn gully, a young life thrown away.

Emily, the ten-year-old subject of a photo from Lauren Greenfield's "Fast Forward" series depicting contemporary youth culture in Los Angeles, appears to be Barbara's opposite. As with Piero's Duke and Duchess of Urbino, the background landscape tells us that the subject dwells high in America's economic and social order.

That status doesn't confer immunity from loneliness. The movie-set background confirms Emily's material security, but highlights her physical and emotional isolation. She's alone in the pool, no other kid in sight, no splashing or swimming going on. Inactivity isn't a tragedy. There's none of the grimness or intimation of violence that envelopes Modica's Barbara. But Emily seems deeply bored, disconnected from the picture-perfect but indifferent landscape surrounding her, as if she's waiting for a more meaningful life in a place she may never find.

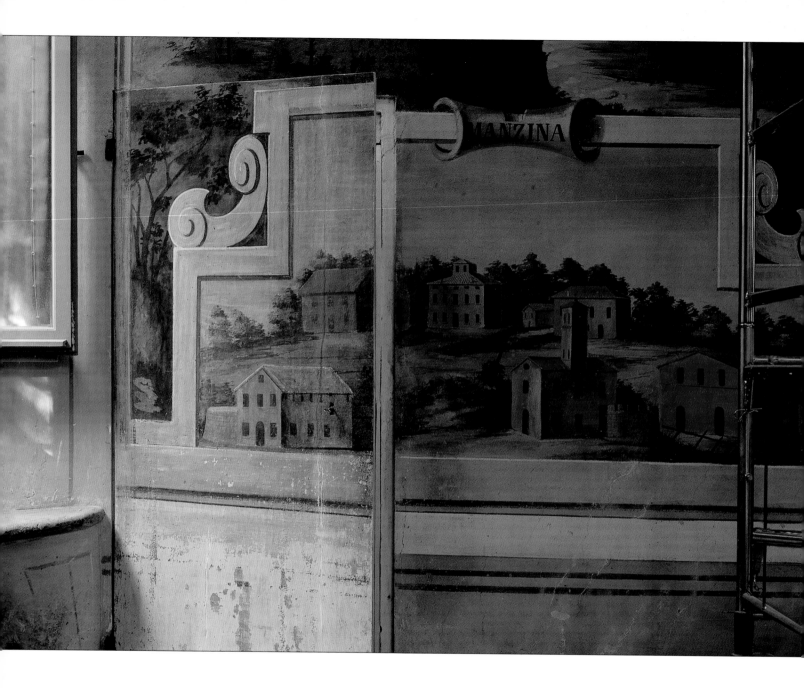

GHIRRI'S DISORIENTING PICTURE EXPLORES HOW WE PERCEIVE AND MENTALLY FRAME IMAGES. THE MURALS ON THE LEFT COVER A HIDDEN DOOR, BRINGING ALDOUS HUXLEY'S "DOORS OF PERCEPTION," TO MIND. MARTIN PARR IRONICALLY EXPOSES THE DISPARITY BETWEEN POSTCARD LANDSCAPES AND MASS TOURISM—PACKAGE TOURS, OBLIVIOUS TRAVELERS, AND SOUVENIRS.

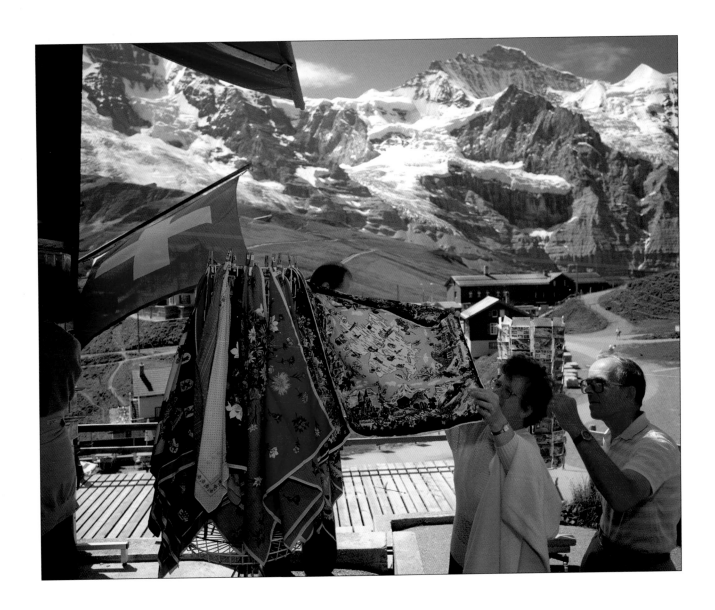

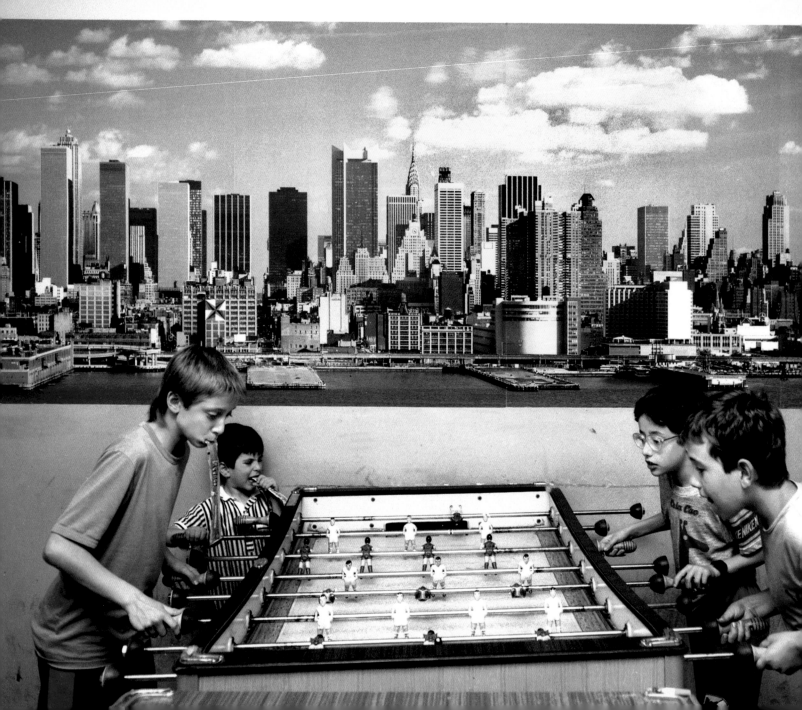

"I WAS PARTICULARLY INTRIGUED THAT REPRESENTATIONS OF SO-CALLED REALITY WOULD END UP BECOMING A FUNDAMENTAL PART OF YET A NEW AND DIFFERENT REALITY, WITH ALL THIS ENTAILS," SENDÓN SAYS. "THE LANDSCAPES THAT APPEAR IN THESE INTERIORS DO NOT APPEAR THERE HAPHAZARDLY. THEY HAVE BEEN CAREFULLY SELECTED FROM AN ARRAY OF SAMPLES OFFERED BY VENDORS OF SUCH IMAGES, WHO SELL THEM BY THE METER."

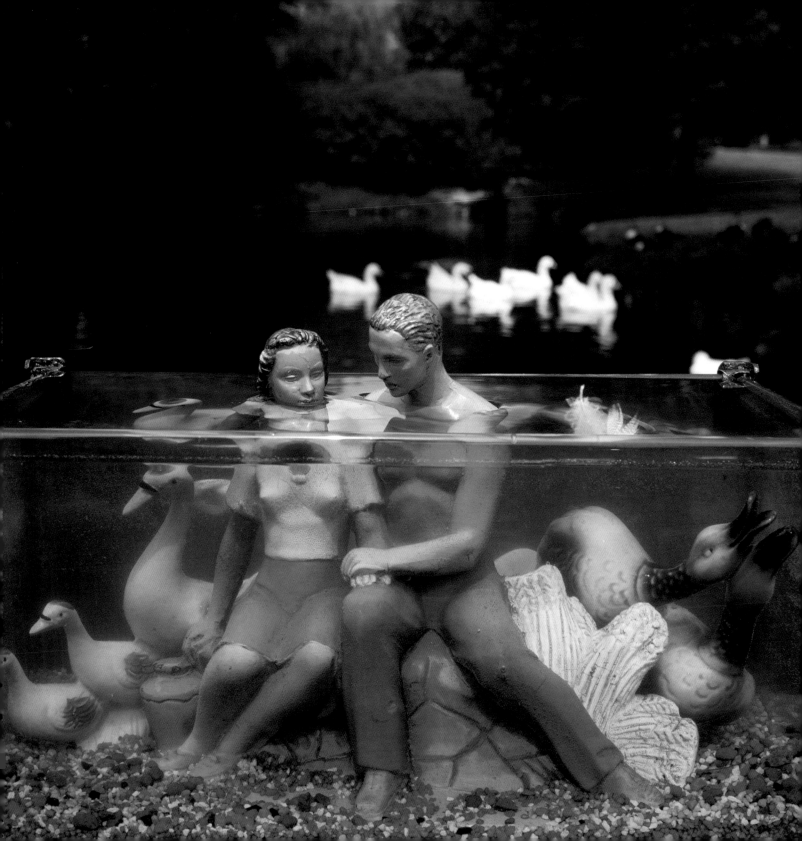

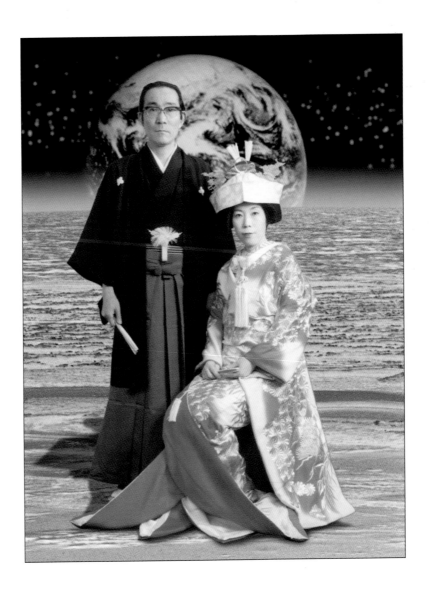

IN HIS DREAMLIKE "FISH TANK SONATA" SERIES, TRESS CREATED ELABORATE SCENARIOS IN A 19TH-CENTURY AQUARIUM, WHICH HE PHOTOGRAPHED IN OUTDOOR SETTINGS. ITAGAKI USES A COMPUTER-GENERATED MOONSCAPE AS WEDDING-PHOTO BACKDROP TO LOOK AT OUR COMPULSION TO USE PHOTOGRAPHS TO PROVE WE HAD A MEANINGFUL EXPERIENCE IN A SPECIFIC PLACE.

RICHARD PRINCE, "UNTITLED (COWBOY)," 1999
WILLIAM ALBERT ALLARD, "CATTLE DRIVE, QUARTER CIRCLE A RANCH, NEVADA, 1971"

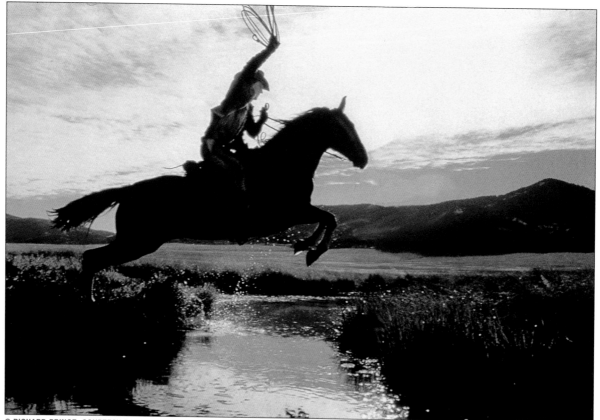

© RICHARD PRINCE. COURTESY BARBARA GLADSTONE

PRINCE'S MANIPULATED IMAGE MELDS THE MARLBORO MAN, PEGAGSUS, AND THE ILLUSION OF
ROCKY-MOUNTAIN-SCHOOL GRANDIOSITY. THE REAL WEST IS ALLARD'S SUBJECT, PLAIN BEAUTIFUL, WITHOUT
BIERSTADTIAN DRAMA. JUST BIG SKY, COWBOYS, CATTLE, AND SAGEBRUSH COVERING A VAST LANDSCAPE.

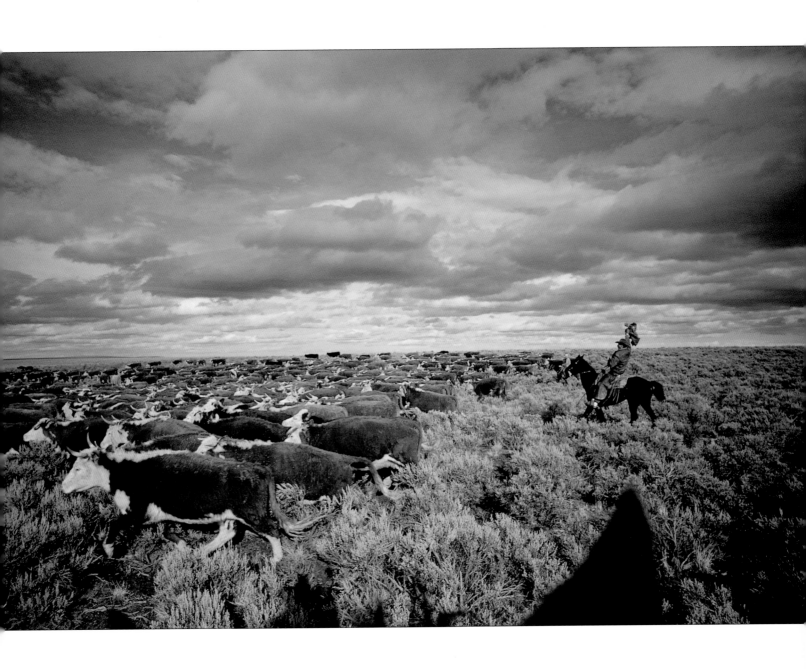

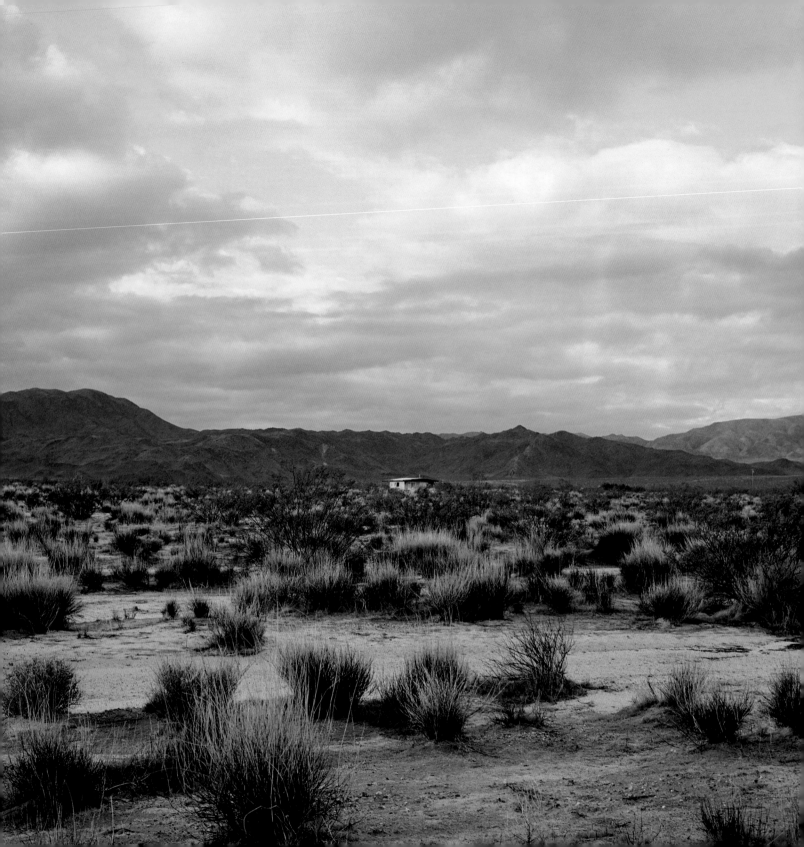

JOHN DIVOLA, "N3407.319"W115 50.987," FROM "ISOLATED HOUSES" SERIES, 1995-98

JIM SANBORN, "106° 48' W 41° 15' N, SHIPROCK, NEW MEXICO," 1995

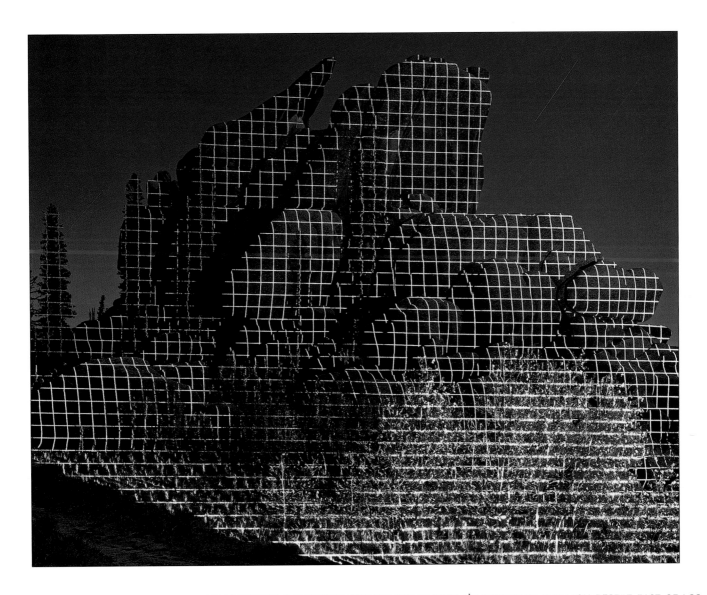

THE LANDSCAPE SUBSUMES THE HOUSES IN DIVOLA'S PHOTOS OF THE HIGH DESERT EAST OF LOS
ANGELES. SANBORN PHOTOGRAPHS HIS LIGHT PROJECTIONS AT NIGHT. "IN THE LAST FEW YEARS IT HAS
BECOME FAR MORE ACCEPTABLE TO MANIPULATE PHOTOGRAPHIC IMAGES," HE SAYS. "THE IRONY IS
THAT BECAUSE OF THAT CHANGE, MY PHOTOGRAPHS MAY BE ACCEPTED FOR WHAT THEY ARE NOT."

ANDREA MODICA, "TREADWELL, N.Y.", 1992
LAUREN GREENFIELD, "EMILY, 10, AT THE PENINSULA HOTEL WHERE SHE LIVED WITH HER FAMILY FOR SEVERAL MONTHS" 1997

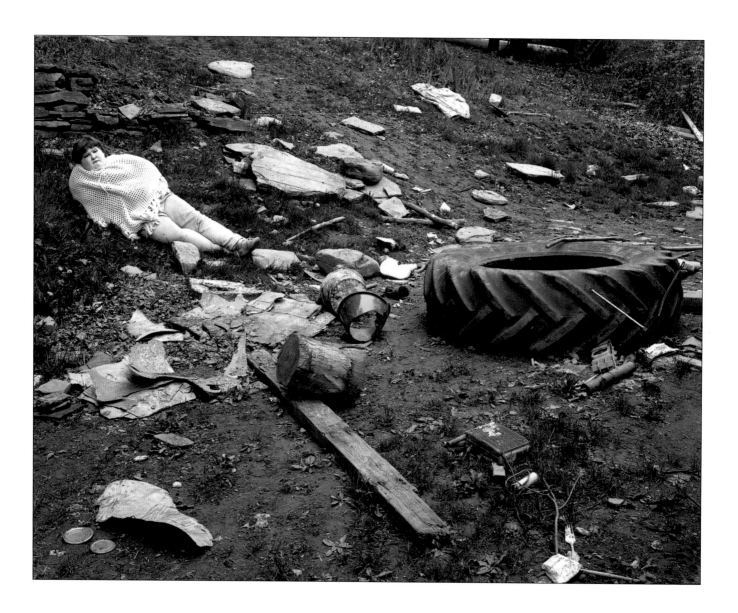

ISOLATED FROM FAMILY AND SOCIETY IN FICTIONAL TREADWELL, BARBARA'S LIFE SEEMS WASTED. MODICA SAYS THE
GIRL WHO POSED AS BARBARA DIED RECENTLY. THE POSH BACKGROUND DOESN'T PROVIDE EMILY IMMUNITY FROM ENNUI.

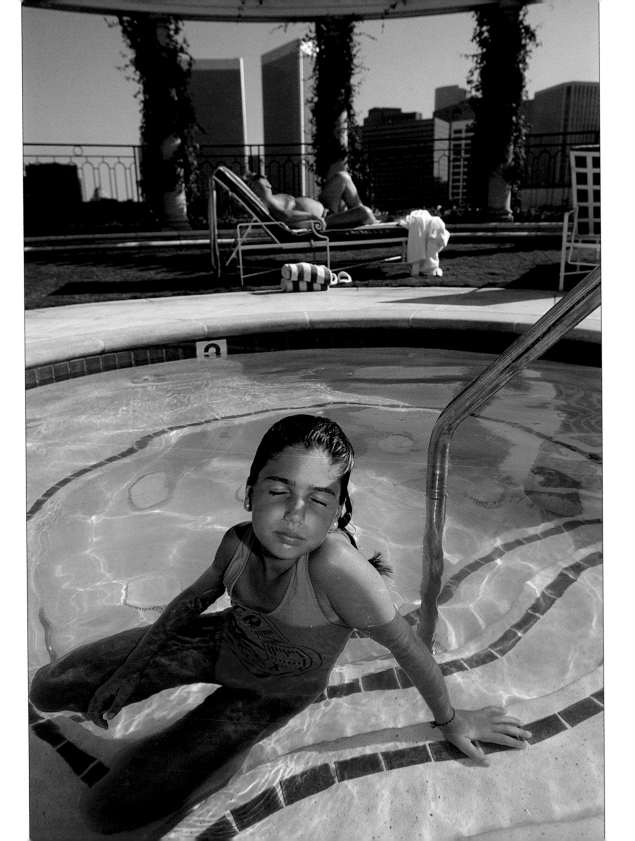

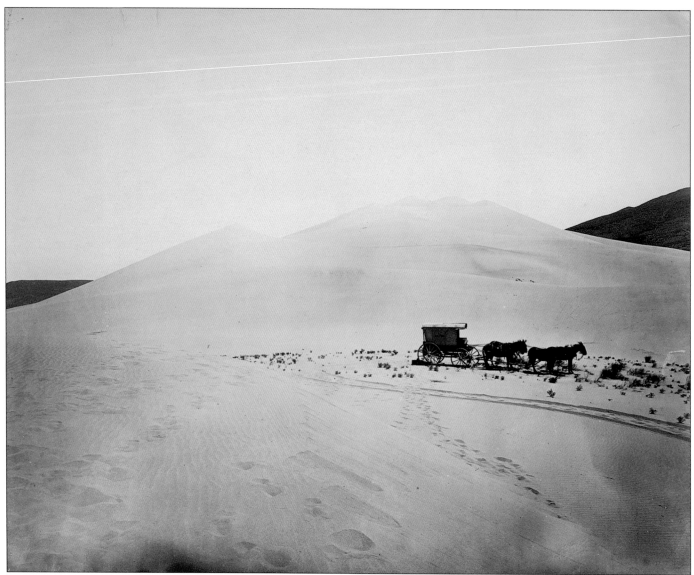

TIMOTHY O'SULLIVAN. © THE J. PAUL GETTY MUSEUM, LOS ANGELES

NO PICTURE WITHOUT PEOPLE

NEITHER PEOPLE NOR OBVIOUS SIGNS OF HUMANITY APPEARED IN MY PHOTOGRAPHS OF THE ILLINOIS PRAIRIE. I went to the nature center, looked through the lens, pressed the button, and reality was converted to a picture through light.

The flatland sunset scenes did more to debunk than prove my vision of a prairie arcadia. Nonetheless, the pictures captured my emotional response to a place I love. The reality of the prairie's beauty flooded through the lens and onto the film. When I look at those photos, a sense of time, place, and myself still resonates. I wasn't in the pictures, but they were about me.

People are present in every landscape photograph, since nature is the external world in its entirety, human beings included. For centuries, that was taken as self-evident and people could be found in landscape art. That changed in the 20th century, when human beings became conspicuously absent in landscape photographs by artists such as Edward Weston and Ansel Adams. The popularity of those pictures elevated photography's status as an art form and, for good or ill, influenced photographic artists the world over.

That influence is still felt, particularly from Adams. Through his force of will and technical wizardry his ideas about the landscape frequently overwhelmed its reality, resulting in pictures possessing an appealing

TIMOTHY H. O'SULLIVAN, "DESERT SAND HILLS NEAR SINK OF CARSON, NEVADA," 1867
SOME POSTMODERN CRITICS SEE THE FOOTPRINTS, HOOFPRINTS, AND WHEEL TRACKS AS A CODE SIGNIFYING AMERICAN SOCIETY TAKING PHYSICAL, POLITICAL, AND CULTURAL CONTROL OF THE WEST BY MEASURING, MAPPING, AND SETTLING IT. BUT O'SULLIVAN'S UNIQUE SELF-PORTRAIT AS LANDSCAPE IS NOT THE WORK OF SOME DRONE FULFILLING AMERICA'S MANIFEST DESTINY.

but stylized beauty. His landscapes are meticulous distortions, orchestral blends of form, texture, and graytones presenting nature as pure and untarnished. Adams didn't want human presence smudging these sublime concoctions. Wouldn't it be great, his photos seem to ask, if we could just keep people out of here?

Fortunately, nature can't be reduced to a sterile, colorless postcard dedicated to aesthetic puritanism and wilderness conservation. Nature is real, colorful, chaotic, and violent, capable of despoiling and even obliterating pristine wilderness through volcanic activity, floods, and fires. Human beings, as messy a part of nature as any, also leave marks, some benign, others not, on the Earth.

Over the past 30 years, this dazzling disorder has taken center stage in landscape photography. By depicting landscape with all its warts and scars, artists around the world are addressing a much broader and more compelling range of issues than their predecessors. By putting people back in the picture they have reinvigorated the tradition of using landscape to examine the complex and evolving relationships human beings have with nature.

That human presence reinforces a back-to-the-future quality typical of many contemporary landscape photos. Some artists seem drawn to the literalism, earnestness, and serenity of photos by the 19th-century masters. Although the technical advances and theoretical approaches to pho-

tography during the 20th century have expanded its possibilities as an art form, its power still lies in the unique qualities that were there from the beginning: No other art form is so fast or literal; none offers such a direct connection between observation and depiction.

Long before modernism, Timothy O'Sullivan was applying photography's intrinsic strengths to the confluence of the human condition, time, and place. "Desert Sand Hills Near Sink of Carson, Nevada," taken as part of a U.S. government survey in 1867, demonstrates his genius. Stripped of wagon, footprints, and tracks, the photo would be an abstraction of four shapes and four tones. Add the human presence and it becomes a self-portrait of the artist, all of 27 years old, yet well aware from photographing the American Civil War's carnage that the sands of time shift quickly and forever.

The people in Igor Savchenko's "Sacred Landscapes" are doing ordinary, everyday things. The picture contains no social or political commentary. Nothing fixes the setting in time or place. The photo looks old, new, and futuristic. Timeless and dislocated, Savchenko's landscape is defined primarily by the act of being photographed, the image this act produces, and the interpretations of the artist and anyone else viewing the image. The result is a deep and wondrous picture, reminding us that the photographic process and the world it depicts are part of a miraculous chain of chem-

ical, physical, psychological, and metaphysical actions and reactions happening simultaneously, called life.

And sometimes we just sit and watch it. "Contemplating the view at Muley Pt., Utah" shows how Mark Klett uses human presence to connect the epic photographs of the American West with contemporary life. The picture is about Klett viewing and recording the way people the world over view natural wonders. We sit on the Earth, dangle our feet over one of its edges, and gaze at the land's imperceptibly changing face as if it were a mesmerizing clock ticking away the slow progress of geologic time. For a few minutes, we're part of something immense and enduring, and eternity holds no fear.

For some people, removing evidence of humanity from landscapes or landscape photographs may offer more room to be inspired by nature's glory. For others, the landscape provides a glimpse of the Supreme Being, as it does in Genesis, the first book of the Old Testament: "In the beginning God created the heavens and the earth. The earth was without form and void, and darkness was upon the face of the deep; and the Spirit of God was moving over the face of the waters."

Or was it Arno Rafael Minkkinen's leg? The Finnish-American artist juxtaposes body parts and picturesque countryside to droll but thought-provoking effect in his photographs, such as "Self-portrait, Foster's Pond,

9/9/1999." Depending on your point of view, the leg and its reflection can be as light as a visual pun or as heavy as the monolith at the beginning of Stanley Kubrick's *2001: A Space Odyssey.*

In Roland Barthes's slim but intellectually weighty book *Camera Lucida*, he wrote, "For me, photographs of landscape (urban or country) must be *habitable,* not visitable," meaning the picture must evoke a certainty that he either has been there or is going there, a feeling he equates with the psychological longing for return to the womb. Barthes also invented the "punctum" of a photograph, "that accident which pricks me (but also bruises me, is poignant to me)." Those ideas come to mind looking at Hiroji Kubota's grim, horizonless "Guangzhou, Guandong." My punctum is the motorcyclist on the entry ramp about to be subsumed by the traffic and smog. Visitable will suffice here.

An-My Le's serene "Ho Chi Minh City" looks like the antithesis of urban Asia's capitalist moil. The title, however, carries a charge. "Any discussion of Vietnam takes place over an open wound," Le wrote in *DoubleTake* magazine. "Forced to leave the country in 1975, at the end of the war, I spent my teenage years in America and Europe, where, behind the absorbing, disorienting surfaces of my new environments, I still confronted images of Vietnam. In magazines or on TV, I'd see burning monks, or children being napalmed."

She found herself looking more at the background of such photos, seeking glimpses of products or pastimes affirming the country's life beyond the war. When she returned to photograph peacetime Vietnam, a quiet calm prevailed. The upturned faces, the strings rising to fluttering kites, and the great expanse of sky make all wars seem like petty squabbles over terrain on short-term loan from some higher power.

Although the sky takes up most of the space in many pictures of the natural world, we still call them landscapes. The misnomer may result from the fact that most of us are more comfortable gazing at our backyard, this little blue planet, than contemplating the vast unknown surrounding it. The infinite contrasted with human finitude can be unsettling. Do we love the landscape because its seeming immutability eases our fear of death? That many explain why death seldom appears in landscape photos.

So Santu Mofokeng's "Chief More's Funeral, Mogopa," is a rarity: a photograph of the ceremony surrounding the passing of a tribal leader. Men walk in front of the hearse and the bus, women behind, while a straggler in the foreground hurries to catch up. Such funeral rituals are universal but vary by culture. This particular scene works as a photograph. Pigment would make the light and space artificial, spawning pathos. The motion of video or film would add linear narrative, emphasizing

life's journey. Mofokeng's photo radiates stoic acceptance of life's end. No matter who we are or what we do, all of us eventually cross the horizon and lose the light.

"Death, then, being the Way and condition of Life, we cannot love to live, if we cannot bear to die," as William Penn, a Quaker leader, wrote in 1702. To love life, human beings need self-knowledge to provide a basis for understanding and relating to the world. Our identities are formed in part by personal histories built from experiences and memories. Riitta Päväläinen's art mimics that process. She installs second-hand clothing in the landscape and photographs it. The clothes can't tell the stories of their previous owners, but their history insinuates narratives. In "Northern Wind," the breeze provides motion. The figure implied by the dress is in flight, yet stuck, bringing an element of frustration. The garment's formal cut and color are out of keeping with the bucolic English setting, suggesting the figure is a person with talent and ambition struggling to break away from a provincial home as the headlike fence post on the far left stands bemused witness.

Identity is a central theme in Maria Miesenberger's body of work. By blacking out the figures in "Untitled (Heimat)," she turns a banal landscape into an unsolvable identity puzzle. Are the figures mother and daughter? Two sisters? Even related? Are they walking toward the camera or away? Is the distance between them

significant? This uncertainty spills over onto the surrounding terrain, which may be benign or, harking back to the prevailing view of landscape in Europe during the Middle Ages, a place where monsters and demons lurk. Perhaps these figures carry their own demons? No answers are provided, just recurring questions that soon spread to the viewer's world.

Reality and surreality are insufficient to describe Allen Dutton's photographs of Sun City, a retirement community in Arizona. Made with an 8-by10-inch view camera, his photos are panrealistic in that they are real, surreal, and seem connected to some future reality.

If one saw only "Eva Williamson, 9425 Arrowhead Drive, 85351, February 1985," the sense of Arizona would be of prosperous people, comfortably retired in a place with tidy lawns made of gravel. Fifteen years later, Eva doesn't live there anymore. In the 1999 photo, the palm tree dwarfs its gravel-star base. An evergreen has been removed, revealing a plate glass window, which mirrors a man standing in the street next to a boxy camera. Retirement in America's Southwest turns out to be a kind of magical mystery tour through the subprime sublime of geriatric suburbia, with Dutton as Salvador Dali Lama cum staff photographer. His Sun City work addresses an ancient paradox of earthly existence, described in 1848 by Johann Nestroy, the great Austrian satirist, in Act I of his farce, *Die Anverwandten* or "The Relatives": "Yes, yes, everything wants to live long, but no human being wants to grow old."

What we want, of course, from ourselves, life, and art, isn't always what we get. The future slips so easily into the present, then it's gone, leaving us to sort through experiences, memories, and photos to determine whether our expectations were met. In archaeological terms, we're judging the marks we left behind. The crowd in Hans van der Meer's "Skater in the Mist" is seen only as blade marks that could have been left by the characters in a 17th-century Dutch painting. Or the lone skater may be the last finisher in the Elfstedentocht, the legendary, one-day, 200-kilometer race through 11 cities in Friesland. Whoever the person is, like all of us he is pushing into the future, hoping the ice stays thick.

IGOR SAVCHENKO, "12.92-95, SACRED LANDSCAPES," 1993

"WE OURSELVES FAIL TO NOTICE THAT / OUR TECHNIQUES OF PERCEIVING THE WORLD / ARE CHANGING. / WE OURSELVES ARE CHANGING. / THE CONSEQUENCES ARE NOT YET CLEAR."
FROM "ON THE ALTERED BEHAVIOR OF SUNLIGHT," A POEM WRITTEN IN 1996 BY IGOR SAVCHENKO.

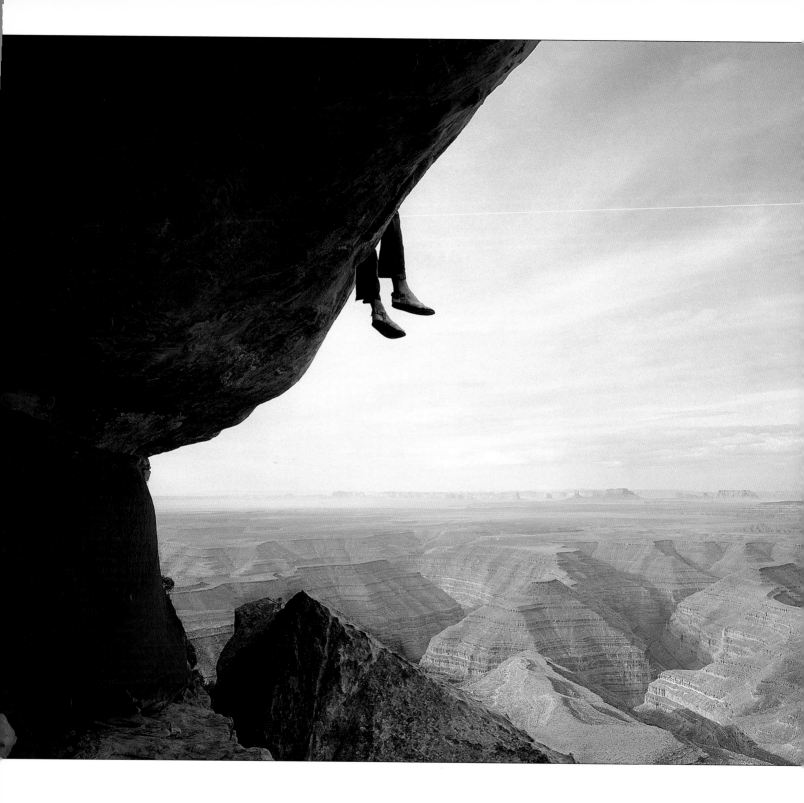

MARK KLETT, "CONTEMPLATING THE VIEW AT MULEY PT., UTAH"
ARNO RAFAEL MINKKINEN, "SELF-PORTRAIT, FOSTER'S POND, 9/9/1999"

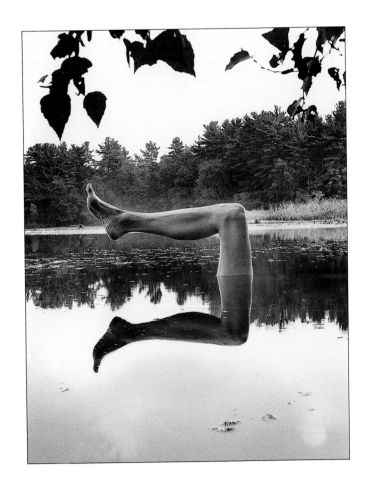

THE EPHEMERAL, A HUMAN BEING, GAZES UPON THE ETERNAL IN KLETT'S MEDITATION ON SEEING, TIME, AND CHANGE. INSTEAD OF LOOKING AT THE WORLD'S OUTER APPEARANCE, MINKKINEN SAYS HE WISHES "TO EXPLORE THE INNER WORLD OF OUR FEARS, HOPES, AND DESIRES IN AN ATTEMPT TO MAKE COMMUNION WITH THE ONE WORLD WE INHABIT."

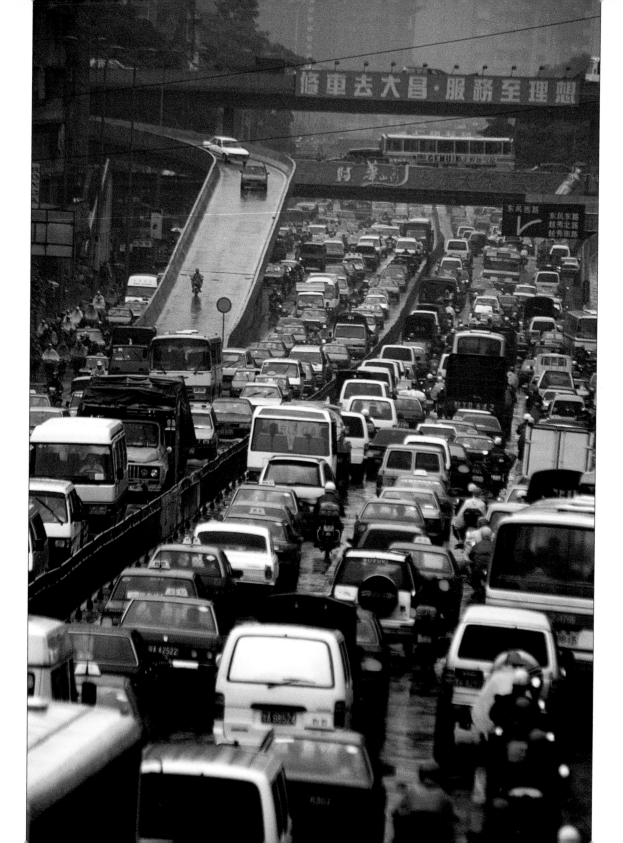

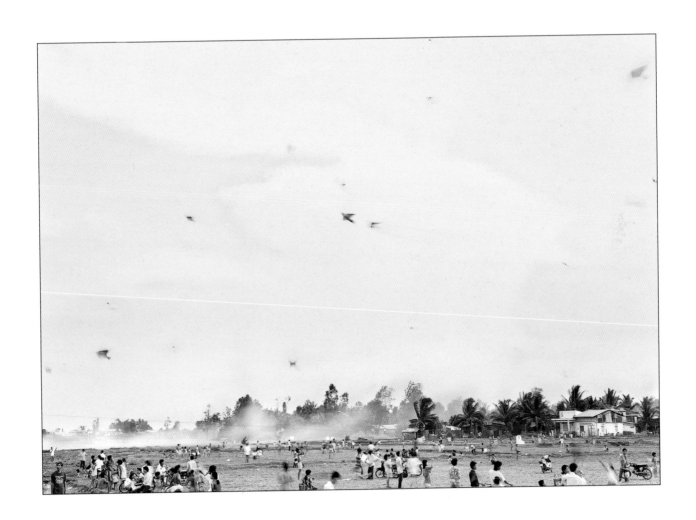

RAMPANT HUMANITY IS THE LANDSCAPE URBAN DWELLERS FACE, AS IN KUBOTA'S PHOTOGRAPH OF THIS CHINESE CITY. LE FINDS PROSAIC GRACE IN A WINDY DAY AS THE RESIDENTS OF WHAT WAS ONCE SAIGON FLY KITES. FOR MANY VIETNAMESE YOUNG PEOPLE THE WAR IS A MATTER OF HISTORY, NOT MEMORY.

SANTU MOFOKENG, "CHIEF MORE'S FUNERAL, MOGOPA," 1997

DEATH IS PRESENT IN ALL LANDSCAPE PHOTOGRAPHS, ALTHOUGH WE SELDOM SEE IT. OUR
EYES AND MINDS FILTER OUT THE FACT THAT AT A CELLULAR LEVEL, LIFE IS A CONSTANT,
CATACLYSMIC CYCLE OF DEATH AND REBIRTH AND SEIZE INSTEAD ON THE MEDIUM'S ABILITY
TO EXTEND THE LIFE OF THE DEPICTED MOMENT'S LIGHT, TIME, PLACE, AND PEOPLE.

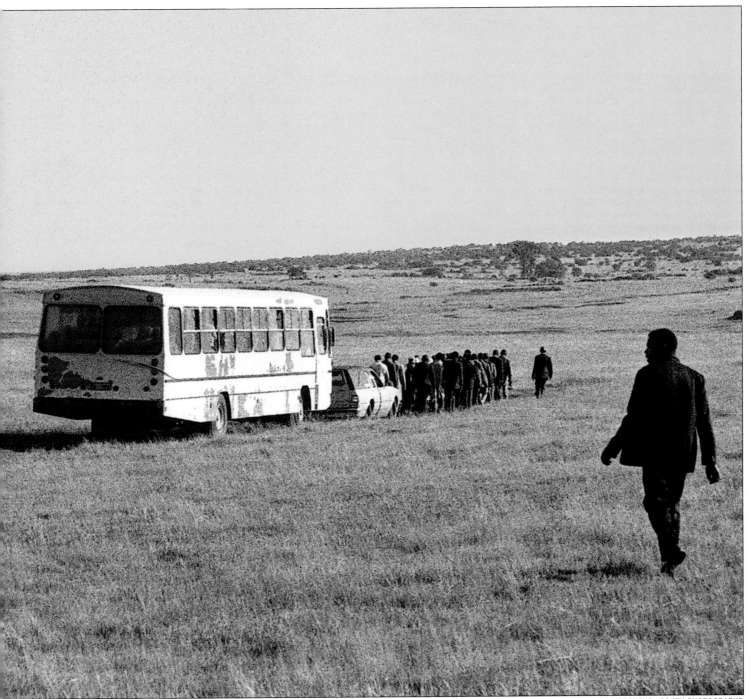

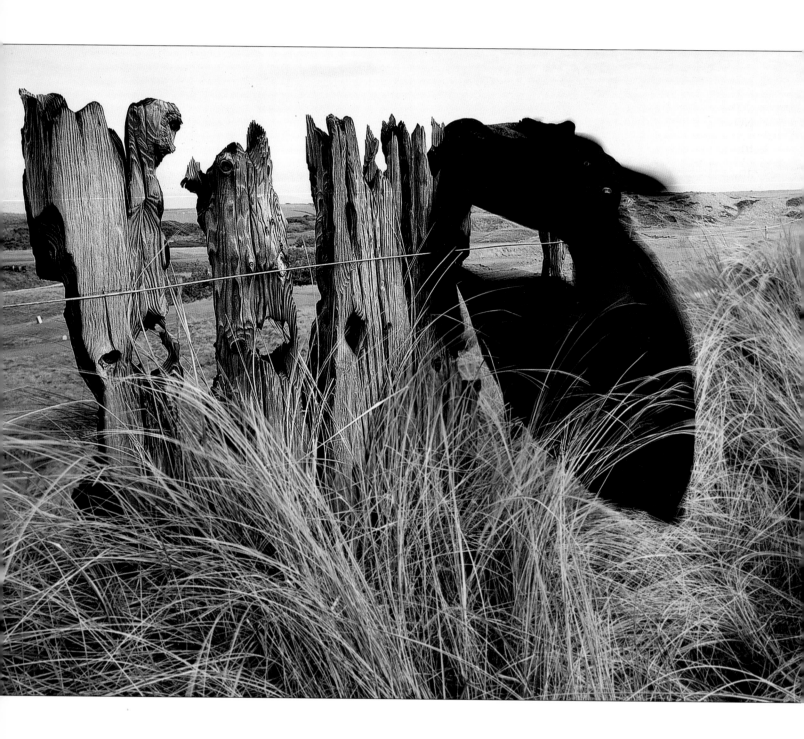

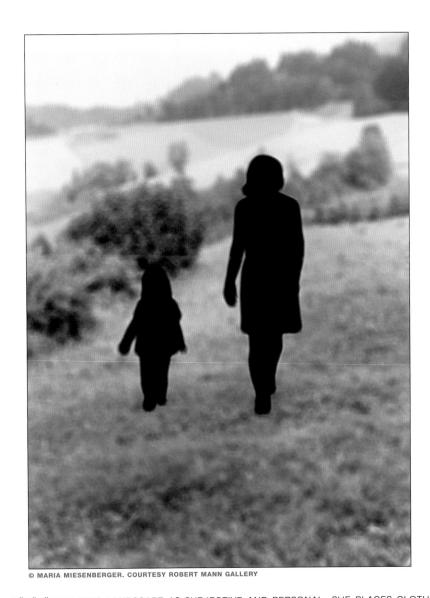

© MARIA MIESENBERGER. COURTESY ROBERT MANN GALLERY

PÄVÄLÄINEN SEES LANDSCAPE AS SUBJECTIVE AND PERSONAL. SHE PLACES CLOTHES
IN IT TO CONJURE POTENTIAL STORIES, IMAGES, AND ASSOCIATIONS. *HEIMAT* IS A
GERMAN WORD MEANING HOME, NATIVE COUNTRY, HOMELAND, AND HOMETOWN.
MIESENBERGER'S FEMALES MAKE AN AMBIGUOUS HUMAN LANDSCAPE.

ALLEN DUTTON, "EVA WILLIAMSON, 9425 ARROWHEAD DRIVE, 85351, FEBRUARY 1985"
ALLEN DUTTON, "9425 ARROWHEAD DRIVE, 85351, MAY 1999"

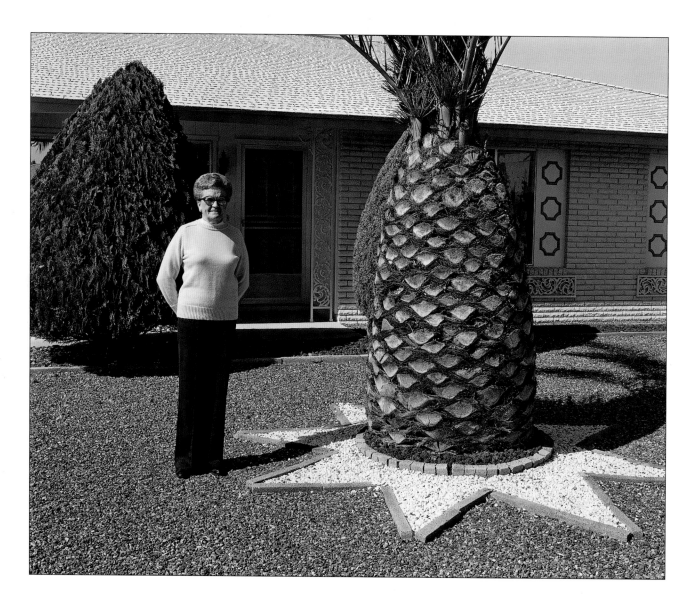

"I DON'T THINK WE CAN BE VERY OBJECTIVE," DUTTON SAYS. "WHY DO SOME YARDS
APPEAL TO YOU MORE THAN OTHERS, SOME WITH BUILDINGS AND PEOPLE, SOME WITHOUT?
YOU'RE PHOTOGRAPHING WHAT YOU WANT TO SEE. YOU'RE PHOTOGRAPHING YOURSELF."

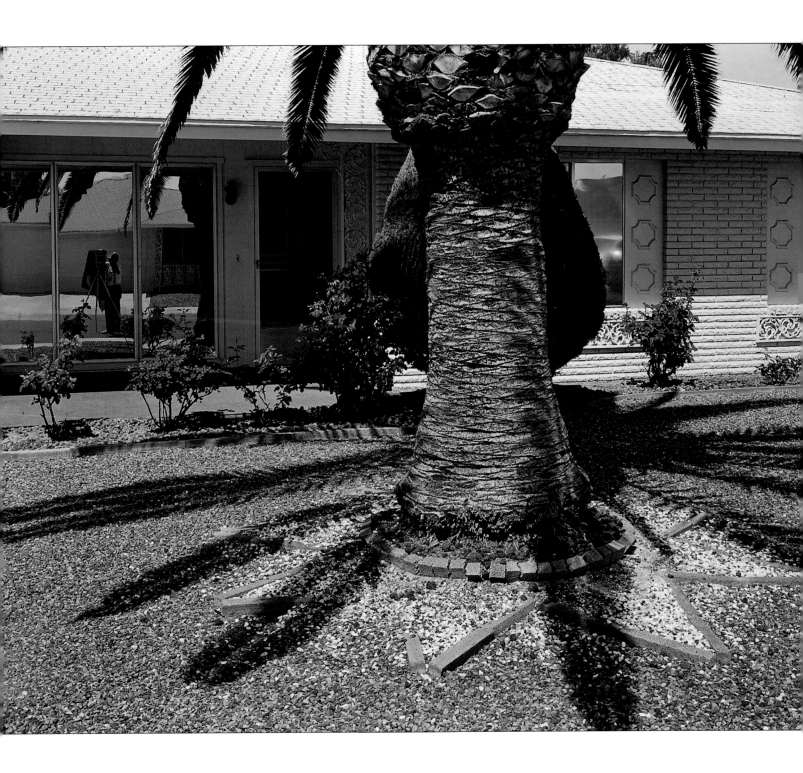

HANS VAN DER MEER, "SKATER IN THE MIST," 19 JANUARY, 2001

IN THIS CHILLY LANDSCAPE, FOG REDUCES THE PASSAGE
OF TIME AND PEOPLE IN SOME PART OF THE NETHERLANDS
TO CARVINGS IN ONE TRANSIENT MEDIUM—ICE, TEMPORARILY
PRESERVED IN ANOTHER—A PHOTOGRAPH.

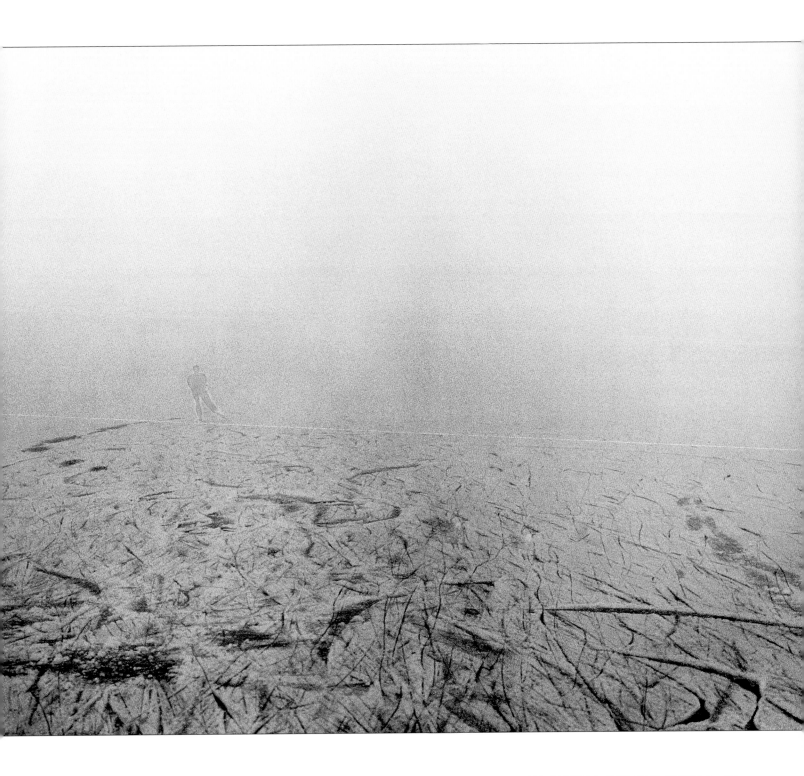

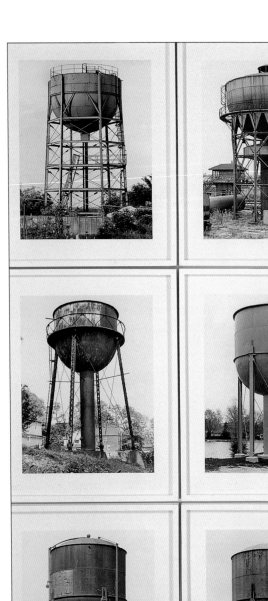
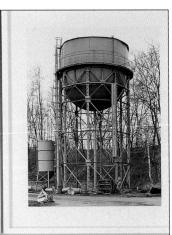
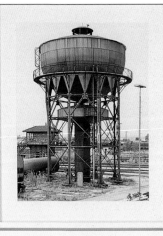
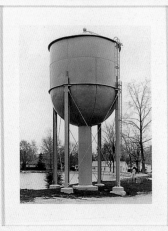
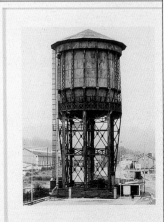
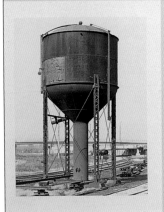
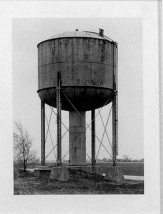
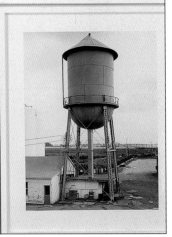

STEELING BEAUTY: INDUSTRIAL LANDSCAPES

EXIT THE AUTOBAHNS CRISSCROSSING THE RUHRGEBIET, GERMANY'S INDUSTRIAL HEARTLAND, AND FACTORIES soon give way to green hills and valleys. Along Kentucky's State Route 42, skirting the south bank of the Ohio River upstream from Louisville, riverine vistas mingle with towering steel, glass, and chemical plants along the two-lane blacktop.

This symbiosis of nature and industry exists the world over, although one wouldn't know it from looking at landscape photography, where nature still rules as if the industrial revolution had never happened. Only in the past 40 years have a relative handful of artists from various countries taken the kind of personal and conceptual approach to the industrial landscape that drives most contemporary photographic art.

Nature's dominance of art has deep roots in many cultures. In the natural landscape, Moses, Jesus, and Mohammed found communion with a greater spiritual force, and philosophers such as Confucius, Edmund Burke, and Henry David Thoreau drew insights into life, beauty, and the human condition.

Industrial landscape has been around for less than two centuries and from the beginning its cultural status was less exalted. Prophets and thinkers didn't trek to the mines or mills seeking truth. Fears quickly arose that factories and railways would spread unchecked, eradicating natural landscapes.

BERNHARD AND HILLA BECHER, "WATER TOWERS," 1980, 61 7/8 X 49 7/8 INCHES
FUNCTION TAKES MANY FORMS IN THE BECHERS' PHOTOGRAPHS OF WATER TOWERS, BLAST FURNACES, LIME KILNS, OIL REFINERIES, AND OTHER INDUSTRIAL STRUCTURES. PRESENTING THESE "ANONYMOUS SCULPTURES" IN ROWS OR GRIDS BRINGS OUT THE DIVERSE STRUCTURAL VARIATIONS ACHIEVED USING JUST ONE MATERIAL, IN THIS CASE, STEEL.

In many places, that happened. At the same time, industry reshaped the way people live. Societies changed from agrarian to urban as people left the land to take industrial jobs in cities. Economies became dependent on the products and prosperity industry generated. The accompanying pollution and social dislocations were accepted as the price of progress. Those developments reinforced the natural landscape's status as a locus of beauty, repose, and meditation. Put simply, natural landscapes were regarded as good, industrial landscapes bad.

That simplistic notion persists, fueled mainly by industry's noxious side effects. But in the early 20th century some artists, notably Alvin Langdon Coburn and Charles Sheeler, overcame the bias toward nature and began photographing the industrial landscape. They were attracted to the subject less by its socioeconomic significance than by its grand scale and sharp-edged, geometric forms.

Most of the artists who photographed the early industrial landscape engaged it from the established perspective of painting. Sheeler's photos of Ford Motor Company's River Rouge plant, for example, reflect the compositional formula for painting natural landscapes developed by Joachim Patenier in Antwerp in the early 16th century. This requires an elevated perspective on a panorama filled with dramatic, detailed geographic formations, with brown tones dominating the foreground, green the middle distance, and blue hues and rugged mountains filling the background. Coburn and Sheeler didn't have color film to work with, but they adopted Patenier's perspective, and rail yards, blast furnaces, and smokestacks substituted nicely for his geographic requirements.

The conventions of painting dominated industrial landscape photography until the late 1950s, when a German couple, Bernhard and Hilla Becher, took a radically new approach. They photographed water towers, blast furnaces, silos, and gas storage tanks straight on from relatively close range in flat, neutral light and displayed the pictures in grids or rows, allowing viewers to compare and contrast the individual subjects, while underscoring their integration as a single art work.

The conceptual power of the Bechers' "typologies," as they call them, relies on photography's literalism and flatness, while their style draws on the work of two 20th-century German photographers, August Sander and Albert Renger-Patzsch, as well as Walker Evans.

Sander created a huge body of portraits of Germans from every walk of life in an effort to classify "all universally human characteristics," thus creating a "physiognomic image of an age." Renger-Patzsch, a force in the "Neue Sachlichkeit," or New Objectivity movement, emphasized precise, accurate depiction and, in his early work, analogies between natural forms and manmade objects. The Bechers' pictures, like Walker Evans's photos of buildings in the American South, seem simple

and straightforward but are actually carefully made to represent not just water towers unto themselves, but the wider world.

Some critics regard the Bechers' industrial physiognomies of our world as cold, rational, and emotionless, a critique drawn more from the German national stereotype than an analysis of the photographs or the artists' intent. That view ignores the main forces driving the Bechers' work: art and love.

Anonymous Sculptures—A Typology of Technical Structures, the title of their first book, published in 1970, illuminates their motivation. Looking at the world around them, the densely populated, highly industrialized Ruhr, the Bechers saw art. Not the didactic art of the cathedral or the clichéd beauty of the cathedral grove, but functional contemporary sculptures. Photography was the perfect way to collect these gems, an industrial process used to capture industry's art. They began searching the world for more examples and have yet to stop.

Doing that requires the almost pathological passion typical of serious artists and collectors everywhere. The Bechers clearly love their subjects and probably keep tabs on the structures and mourn when they are torn down, something that happens often these days as industries move to the developing world. The couple isn't asking whether industry is good or bad, or if technology means progress. They collect and catalogue

small, man-made wonders, reaping strange beauty before it is destroyed.

Stuart Klipper's panoramic "RR line, farmstead with Esso sign, I-89 overpass, central Vermont," from his "The World in a Few States" series, might seem like the antithesis of the Bechers' work, with its depth, scope, and formulaic colors, brown foreground, green middle ground, and blue hills in the background. But this is no Patenier idyll. Where the Bechers used small pictures to build a world, Klipper saw and photographed a world built of many small pictures in which the symbols and metaphors of nature and industry confront each other. The farm is a donnybrook of juxtapositions, such as oil, embodied by the Esso sign, losing a battle with vegetation. Ultimately, these struggles become one: man battling invulnerable time at the intersection of nature and industry.

An industrial plant towers above tidy homes and a man mowing his steep lawn in Andrew Borowiec's "Monongahela Valley, Pennsylvania." Along this tributary of the Ohio, the natural and industrial landscapes seem to coexist like old, fairly friendly neighbors.

Borowiec spent 13 years photographing the Ohio River Valley, from steel mills near Pittsburgh to southern Illinois farms 650 miles downstream. His photos look at the region described by Alexis de Tocqueville as "one of the most magnificent valleys in which man has ever lived" without prejudice, accepting the reality of people

and industry living close together. "Appreciating the Ohio requires a rarer and more inclusive idea, one of a beauty that exists not despite but thanks to mankind's shaping influence on the landscape," Borowiec wrote in his book *Along the Ohio*.

Mankind's influence fairly reeks from John Pfahl's "Bethlehem #16, Lackawanna, NY," but its beauty is undeniable. Seen through Pfahl's telephoto lens, the acrid smoke billowing from a coking plant becomes a majestic cross of Alvin Langdon Coburn's cloud studies and J. M. W. Turner's impressionistic paintings of speeding steam trains. This smoke is, of course, full of toxic compounds. Sudden wind shifts sometimes enveloped Pfahl in his subject, forcing retreat to his car. Terrible as that pollution was, from a purely aesthetic viewpoint the interplay of man-made clouds, wind, and sunlight that Pfahl found is fascinating.

Human industry's presence in landscape is often less ethereal and literally more concrete. No substance is more ubiquitous in industrial societies. None has played a greater role in reshaping the Earth. Yet, just as people are present, if usually unseen, in landscape photographs, so, too, is concrete.

Deconstructed, it consists mainly of sand, gravel, limestone, and water. Regardless of the symbolic significance various cultures attach to those materials, their origin in nature is indisputable. Mixed and cast as concrete, how-

ever, they seem contrary to any notions of the sublime, picturesque, or beautiful. Even after industrial processing, however, nature's evocative power is not easily suppressed.

"Grande Dixence Staudamm," in Switzerland, is part of Johann Hinrichs's series of photographs of Alpine dams that highlight the interaction of architecture and nature. His Grande Dixence serves as an anti-vista. In tourist postcards or paintings by Caspar David Friedrich, an alpine valley invariably is accompanied by a view into the distance meant to entice travelers or serve as an allegory for the unknowable future. By photographing the dam as a motorist sees it, Hinrichs creates a study of comparative forms, textures, and colors, a tense face-off between the architecture of plate tectonics and man that negates the romantic view of the Alps.

The concrete in Hans-Christian Schink's "ICE-Strecke bei Gardelegen," in eastern Germany, serves manifold architectural, sociological, and pictorial functions, some intended by the builders of the depicted ICE high-speed train line, others created by the artist's eye.

The track was built by the German railway after unification in 1990. If unity is measured by track laid and concrete poured, then Schink's photo testifies to its success. But from beneath the rails, we don't see the sleek trains blasting by above at over 200 miles per hour. From above, the passengers can't see the snapshots framed by the concrete supports. Schink uses such sharp

contrasts between man-made and natural forms and monotone concrete and nature's variegation as dialectical elements in a meditation on the political and cultural meanings of division and unity. The trains don't stop at small towns like Gardelegen. This suggests the new infrastructure linking German cities hasn't brought the people living along the right-of-way in the country's east any closer to their fellow citizens in the west.

No political or sociological agenda is present in Toshio Shibata's photographs. Commissioned in the late 1990s by the Museum of Contemporary Art of Chicago to photograph the American landscape, Shibata felt challenged by the country's physical size, which is immense compared with his native Japan. By focusing on structures such as dams, spillways, and retaining walls, he distorts the landscape's scale, giving intimacy and fresh mystery to epic landmarks, as in his "Grand Coulee Dam."

The two main plumes of water streaking down the concrete dam face are ethereal but powerful, and create an optical illusion making the striations in the concrete seem to vary in length, calling into question the dam's physical integrity. The industrial landscape becomes a pure abstraction, disassociated from time, place, and its makers.

In many of Jim Cooke's photographs, on the other hand, industry and human endeavor are real and present, whereas nature is marginal bordering on dissociative. Cooke's "Containers, Antwerp, Belgium" is a typi-cal edge-city industrial environment bathed in the Low Countries' skimmed-milk sunlight. Rails, catenaries, and supporting posts carry the eye into the middle distance, past containers stacked like a colorful wall of shoe boxes. What nature we see, the strip of scrubby grass and the ballast, is shaped by man. Even so, the natural landscape comes across as more enduring. The wires, rails, and containers require regular maintenance to exist. For the grass and weeds, maintenance is required to suppress their relentless natural vigor.

Nature is almost invisible in Fay Godwin's "Carwash, Bradford," an urban industrial landscape as a mélange of dichotomies. Purely as forms and colors, the scene is beautiful, bleak, and mesmerizing, akin to a Roger Fenton photo shot in color. The factory roof marches to a Precisionist beat. In the background, the smokestack rises like a minaret from which the whistle calls the faithful to labor.

Viewed as a place to live, however, this chunk of Bradford is surpassingly ugly. There's mild irony but no curb appeal in an open-air car wash surrounded by trash and grime. Even the light seems dingy. But people do live in close quarters with industry, as the chatting women attest. Godwin's art often has a sociopolitical edge. In this case, however, the only apparent agenda is fascination with the wonders of human life in an industrial world that even Burke might find sublime.

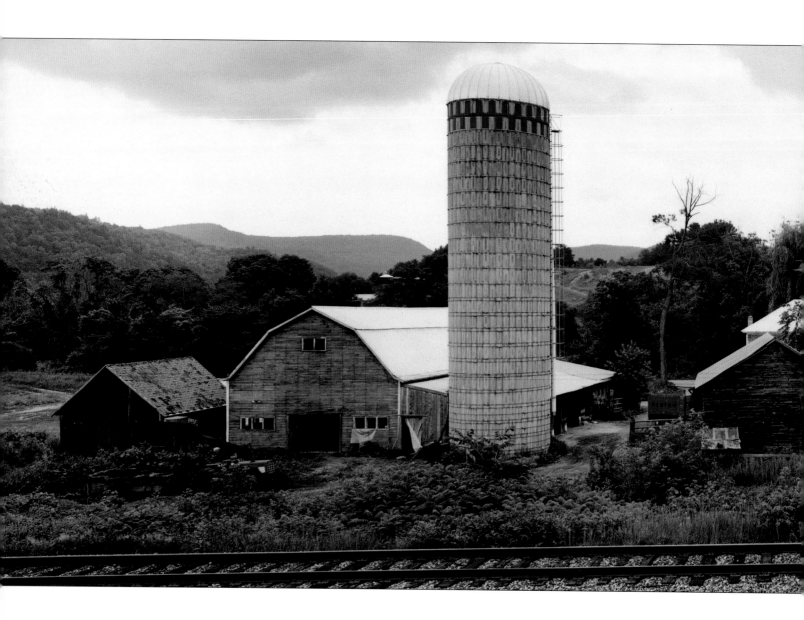

KLIPPER OFTEN PHOTOGRAPHS PLACES THAT ARE "FRAUGHT WITH A POTENTIAL FOR SYMBOL AND METAPHOR—MEANS
BY WHICH WE CAN TALK WITH ONE ANOTHER AND, PERHAPS MORE CRUCIALLY, PLACES CHARGED WITH TRANSCENDENCE,
IMMANENCE, ILLUMINATION AND THE LOOM OF EPIPHANY—MEANS BY WHICH WE MIGHT TALK TO GOD."

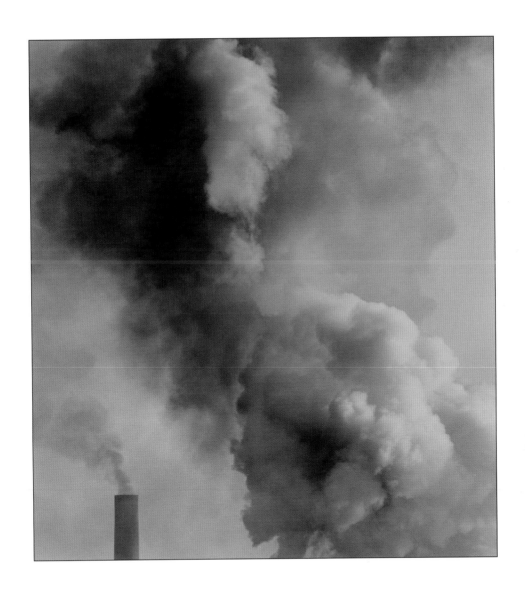

INDUSTRY, PEOPLE AND SCENIC NATURE SHARE SPACE IN ANDREW BOROWIEC'S
PHOTOS OF THE OHIO RIVER AND ITS TRIBUTARIES. JOHN PFAHL FOUND PAINTERLY
RESPLENDENCE IN THE SMOKE OF BETHLEHEM STEEL'S COKE OPERATION.

JOHANN HINRICHS, "GRANDE DIXENCE STAUDAMM," SWITZERLAND/VALAIS, AUGUST 2000
FROM "STAUDÄMMER IN DEN HOCHALPEN" SERIES
HANS-CHRISTIAN SCHINK, "ICE-STRECKE BEI GARDELEGEN," 2000

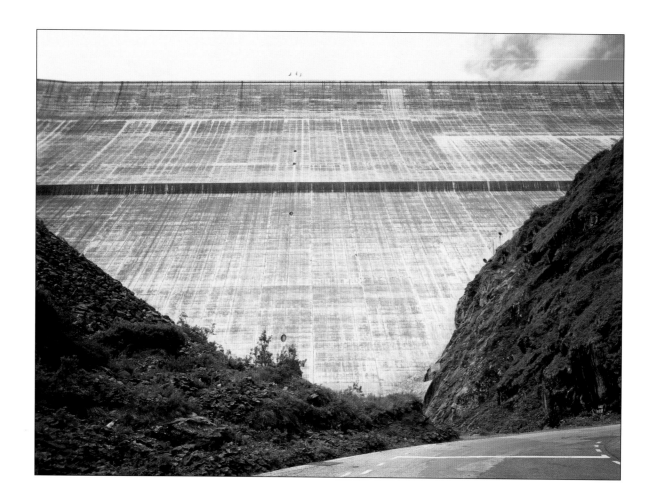

HINRICHS SHOT THE DAM, ONCE THE WORLD'S TALLEST, FROM THE ROAD, CREATING AN ANTI-VISTA OPTICAL ILLUSION.
THE CONCRETE LOOKS LIKE A HIGHWAY RUNNING BEHIND THE MOUNTAINS. SCHINK USES THE PILLARS TO BRING MOVEMENT
AND DEPTH TO HIS PHOTO OF A HIGH-SPEED TRAIN LINE IN THE EASTERN GERMAN STATE OF SAXONY-ANHALT.

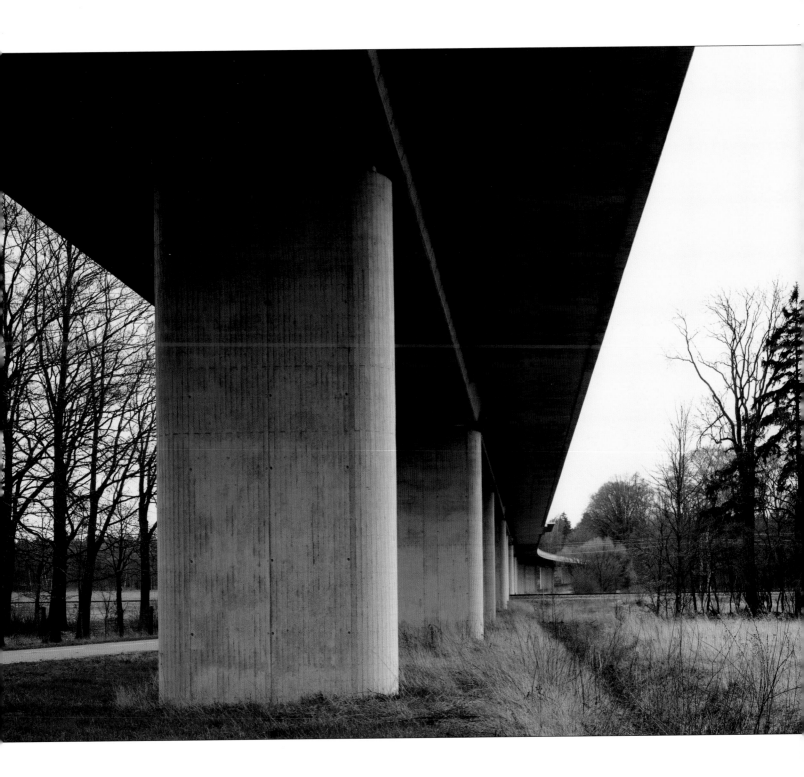

TOSHIO SHIBATA, "GRAND COULEE DAM, DOUGLAS CO. WA, 1996"

THROUGH CAREFUL FRAMING, USE OF BLACK-AND-WHITE FILM, AND LONG
EXPOSURE TIMES, SHIBATA DISTILLS THE CONFRONTATION OF BUILT AND NATURAL
LANDSCAPE TO AN AESTHETIC ESSENCE OF LIGHT, TONE, AND FORM, GIVING
FRESH BEAUTY AND MEANING TO THE FAMOUS AMERICAN DAM.

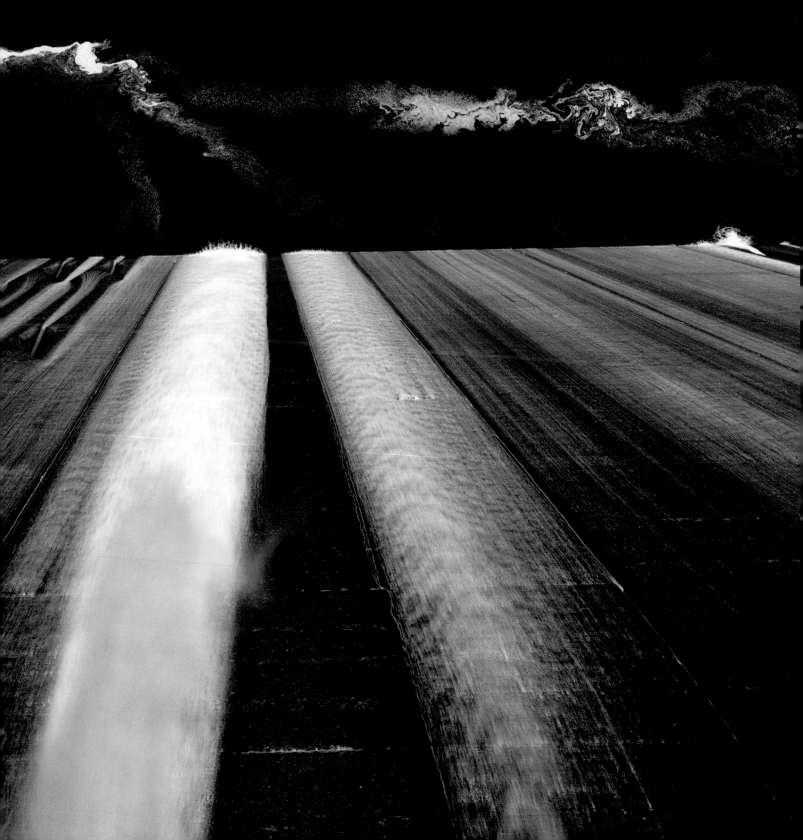

JIM COOKE, "CONTAINERS, ANTWERP, BELGIUM," 1998
FAY GODWIN, "CARWASH, BRADFORD," 1987

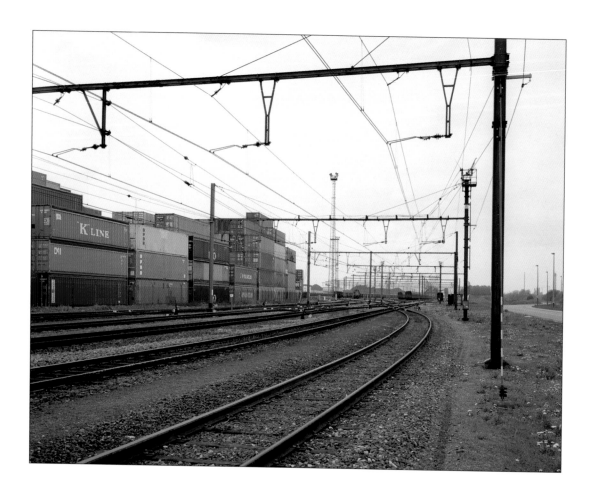

JIM COOKE'S SERIES "RE-PLACING ARCADIA" EXAMINES THE AESTHETIC AND CULTURAL ASPECTS
OF LAND USE. FAY GODWIN IS ONE OF BRITAIN'S BEST-KNOWN LANDSCAPE PHOTOGRAPHERS.
HERE, THE GLARINGLY RED CAR WASH COULD BE ONE OF THE BECHERS' ANONYMOUS STATUES,
A JEAN TINGUELY CONTRAPTION OF INDETERMINATE FUNCTION, OR AN ALIEN LIFE FORM.

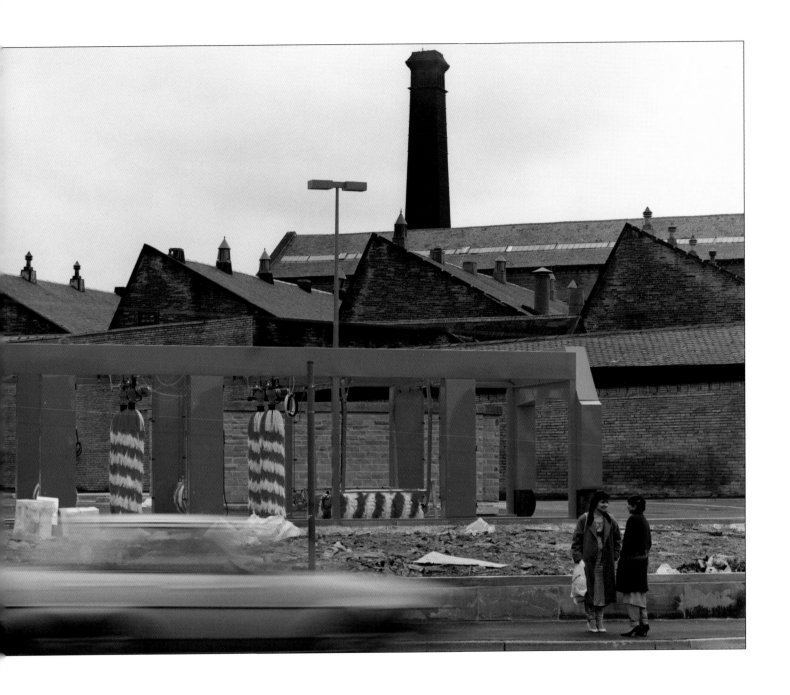

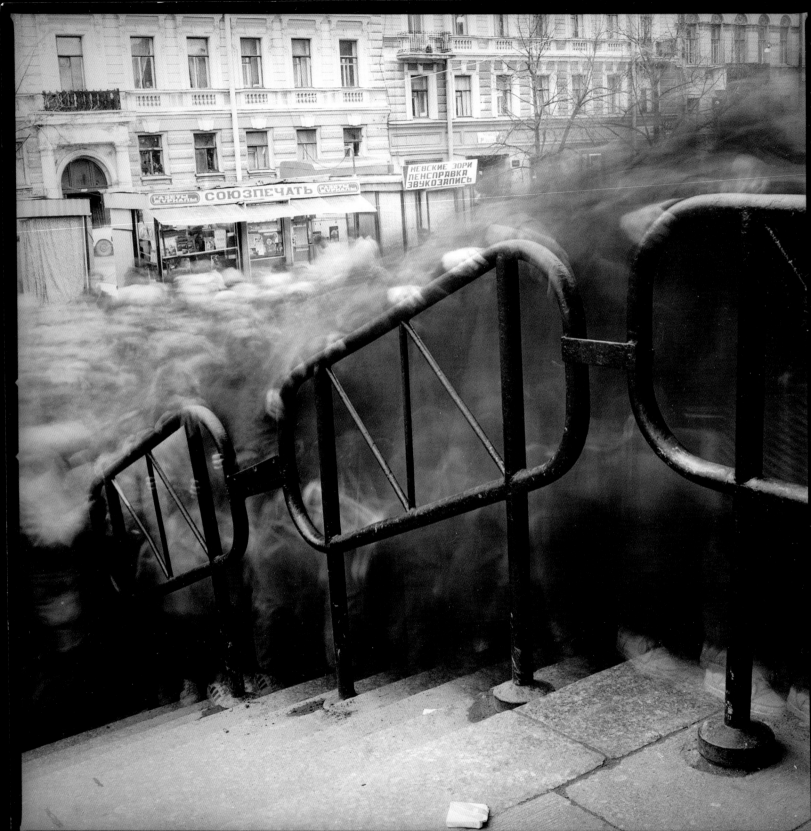

BETWEEN GRIT AND GRACE

NOWHERE ARE THE EFFECTS OF MANKIND'S SHAPING OF THE LANDSCAPE MORE CONCENTRATED THAN in cities, where the natural terrain has been overlaid or obliterated by centuries of human habitation and endeavor.

Experienced live, the city landscape is imposing, changeable, and intemperate, moving between the extremes of appearance and reality, posing as a postcard skyline one moment and a shooting gallery full of human targets the next.

The city's shape-shifting presence has been a prime attraction for photographers since the medium was invented. In the 20th century, modernists such as Alfred Stieglitz were enchanted when weather or nightfall bathed New York City's streets and skyscrapers in grace. Brassaï and Henri Cartier-Bresson and others were taken by Paris's effervescent life and its visual appeal.

Alluring as the city's physical appearance remains, contemporary photographic artists around the world are looking not just at its formal aesthetic qualities but at how it functions as a sociological and psychological space. Artists such as Alexey Titarenko depict the urban landscape as part of a complex social reality rather than a thing unto itself.

ALEXEY TITARENKO, "UNTITLED (CROWD 2)," FROM "CITY OF SHADOWS" SERIES, 1993
TITARENKO'S IMAGE OF ST. PETERSBURG PRESENTS THE COMPRESSED URBAN SPACE AS ABOUNDING IN DICHOTOMIES AND GRAY AREAS. IN BIG CITIES, BEAUTY AND UGLINESS, WEALTH AND POVERTY, EDUCATION AND IGNORANCE, VIOLENCE AND SERENITY ARE NEVER FAR APART.

In St. Petersburg, as seen in Titarenko's "Untitled (Crowd 2)" from his "City of Shadows" series, a crowd moves herdlike up one side of a set of steps. Why is unclear. The time exposure turns the people to dismembered wraiths flowing past in an almost amorphous mass. Their ghostliness highlights the anonymity and regimentation of city life and evokes the dead, the ever growing ranks of those who lived, died, and are still present as memories. This dark cloud of humanity, punctuated only by a few hands, feet, and blurred facial features, also calls to mind the grim photos of Jews being rounded up by the Nazis, as well as the irrational, morally indifferent masses that Elias Canetti identified as the seedbed of fascism in his masterwork, *Crowds and Power.*

The lighter tones of the building facades in the background, the geometry of their windows, and the bare trees provide a visual and emotional counterpoint, brightening the picture and its frame of reference. Perhaps this is just an audience leaving an open-air performance, or an artists' collective creating a live variation on Marcel Duchamp's "Nude Descending a Staircase." Focusing on the steps recalls André Kertész's 1927 photo "Montmartre, Paris" and the Odessa Steps scene from Sergey Eisenstein's film *The Battleship Potemkin.* Using traditional photographic methods, Titarenko, like a number of contemporary artists in various countries, mines such metaphorical and associative possibilities from the city's physical and psychological interstices.

Among the first to explore such spaces was Robert Frank, a Swiss-born photographer, whose photos of the United States in the 1950s presented cities and suburbs as a gritty mélange of blank walls, blank stares, and American flags. Influenced by Frank, many younger photographers, notably the "New Topographics," as Lewis Baltz, Robert Adams, and others were labeled in the 1970s, took a cold-eyed bead on the urban landscape. Rather than Modernist romanticism, their photos were informed by conceptual and minimalist art, then the rage in Manhattan.

They caused a sea change. For the first time, leading East Coast galleries embraced photography, picking up many of the "New Topographic" artists. Since then, revenue from print sales has helped photographers such as Abelardo Morell pursue their individual visions and further expand the boundaries of urban landscape photography.

In Morell's "Camera Obscura Image of Boston's Old Customs House in Hotel Room, 1999," the city, usually depicted as outdoor space even though the cultural, social, political, and economic activities that distinguish its life occur indoors, is turned upside down. Morell connects the two realms, highlighting the indirect way many of us actually experience the landscape: as a photograph seen indoors. The lengthy exposure his technique requires also

dissolves the city's traffic, its inhabitants, and the hands of its clocks, turning the time-space continuum into a gray scale filling the space between appearance and reality, direct and indirect experience. As Jimi Hendrix sang in "Purple Haze," "Is it tomorrow, or just the end of time?"

The camera obscura yields different results in Vera Lutter's "333 North Michigan Avenue, Chicago, Il: October 16, 2001." The people and traffic are also gone from Chicago's "Magnificent Mile." The viewer looks out at strangely incorporeal buildings that seem made of light. It's a spectral and beautiful image, haunting the mind with thoughts of what existed before Chicago was built and what it might be like without people.

Tropical heat has emptied the public thoroughfares except for a lone man striding down the deserted street in Luca Pagliari's "La Habana #14." The weathered buildings and blurry background give the impression of a city where nothing is new except the day melting away. Pagliari's picture is a meditation on time, physical decay, and the significance of an isolated individual in a mass society.

An air of detachment also permeates "Hanoi," by An-My Le. The white school looks new. The students congregate and wander off, just as they do everywhere. The anxiety and urgency that gripped this city when it was repeatedly bombed during the Vietnam War is long gone. But the elevated viewpoint suggests Le sees her native land with fondness but from an emotional dis-tance. Her picture is a bittersweet reminder that photographing the landscape is an art of the interstices, in which the space intervening between things such as the artist and the subject or the viewer and the picture not only conducts but also generates meaning.

The swarms of people, vehicles, lights, and colors in David Alan Harvey's "Via Toledo" show the urban land-scape's intense side. The weight of the picture is on the long street, a blur of cosmopolitan life in which Italy's history is reduced to a stone portal, possibly part of a church, in the upper right-hand corner. It's shuttered and dark in marked contrast to its well-lit neighbors like the café named Désirée, where even a saint might take an occasional coffee break.

Johannesburg, South Africa, as seen in Stephen Hobbs's "Urban AntiNarrative #22," isn't bustling with ordered chaos. It's a city in transition. The old order, the system of apartheid that banned blacks from living in the urban center, has crumbled. The new Johannesburg is an African metropolis open to all. By zeroing in on the places where the citizenry's behavior conflicts with the civic social structure, Hobbs turns a crumbling, urine-soaked wall into a metaphor for Johannesburg's ongoing and wrenching physical and social transformation.

Sebastião Salgado has been using photography to investigate social transformations for some 30 years. Between 1994 and 2001 he produced his "Leaving the

Land for the Cities" series, examining migration and the changes that occur when traditional ways of peasant life are transplanted into an urban environment. In his picture of Shanghai, the exercising peasants seem oblivious to the capitalist juggernaut just across the river. Peasants who've migrated to Ho Chi Minh City roost like birds on the window ledges, seemingly unperturbed by their move from a horizontal to a vertical village. These dichotomies of urban life—wealth existing next to poverty, beauty beside ugliness, tradition confronting change—become epic, everyday wonders in Salgado's photographs.

Without the postcard quality color can convey, Shirana Shahbazi's "Teheran-02-2000" would lose its force. With color, she creates an appealing ordinariness that highlights the modern look and beautiful setting of a city whose name conjures up images of Islamic revolution and a rigid, theocratic state. With cool subtlety, Shahbazi presents an aesthetic vision of a Teheran that seems quite familiar—vibrant, complex, changing—and totally contrary to the stereotype of Iran as a static society divorced from modernity.

Ola Kolehmainen's photographs explore the minimalist beauty that abounds in postmodern urban life. His large-format pictures are detailed examinations of what he considers the bare essentials in a space, building, or structure. "Tour Finances" reduces civic architecture to a multilayered geometric abstraction built of repetitive forms. The photograph transforms the three-dimensionality of these features into planar surfaces, as the Modernists did, but with a significant twist.

Such flattening is inherent to the photographic process and has long been considered one of the medium's greatest limitations. As Roland Barthes wrote in *Camera Lucida,* "I must therefore submit to this law: I cannot penetrate, cannot reach into the Photograph. I can only sweep it with my glance, like a smooth surface. The Photograph is *flat,* platitudinous in the true sense of the word.…"

Barthes wrote those words around 1980, in reference to photographs he could hold in his hand. Much has changed since then. The presumption that photography is innately objective no longer holds sway. Photos can also be blown up to enormous size and printed with dazzling detail, a phenomenon pioneered by contemporary German photographers such as Thomas Struth and Andreas Gursky.

Sheer size has its advantages and disadvantages. Reconstituting the architecture in Kolehmainen's "Tour Finances" at 160 x 228 centimeters makes the three-dimensional detail of the planes reemerge, revealing new spatial juxtapositions between the architectural elements, the viewer, the picture, and its surrounding space. Unlike many of the Germans' big photographs, this transformative quality doesn't dissolve on close

inspection, so his picture becomes a trenchant look at the urban landscape's mutable essence.

Urban space is examined from a more sociological viewpoint in Wolfgang Tillmans's "Palisades." An unusually empty expanse of California street takes up more than half the picture. From Tillmans's bird's-eye view, the park is an open-air stage, the people atomized players. A hooded man with a shopping cart is frozen as he gestures beseechingly or angrily at a red-haired woman frozen in full stride by the camera. The man mowing watches them. His colleague chats with the girl on the bench. A white-clad senior citizen approaches. Such scenes play out in parks everywhere. The world, as German Expressionist Max Beckmann once wrote, "strikes me as a hurdy-gurdy over-pressurized with trite rechurning." And as Tillmans shows, every day, from Bangkok to L.A., art happens.

Sometimes it happens on a vending machine. What better place for a photographic landscape, since such images are a standard marketing tool? Sam Abell found a quintessential photograph of the western United States on a machine in a Japanese city, which we don't see in his picture, although you can almost hear its din pressing on the machine. The vending-machine picture, splattered with mud and marred by tape, shows a four-lane highway running from the viewer into the American West. Abell saw the art in this commercial banality and created a picture of a picture of a myth about a place just beyond reach: paradise.

Reality isn't mythic in Manhattan; it just seems that way. Everything is bigger, faster, louder, more pressurized. Aside from Central Park, places where one can stretch one's legs in green space are few and far between. So the High Line is an anomaly: a 1.45-mile stretch of abandoned, elevated railway running from 34th Street through the arty precinct of West Chelsea to the meatpacking district. There are no people on the tracks in Joel Sternfeld's "Looking East on 30th Street on a Morning in May," but the human presence weighs heavily indeed.

The roadbed recedes to a vanishing point by the Empire State Building and time moves more slowly as the blooming flora obeys its seasonal clock. The High Line isn't paradise, but walking along it, above the city traffic, seems like a stroll in that direction. But in Manhattan, home to some of the world's priciest real estate, nothing is that simple. The High Line isn't a public right-of-way. It's built on private property in a hot neighborhood. Developers are eager to rip it down and build anew. A coalition of residents, artists, and nature lovers is resisting. Both sides exert intense pressure. For the time being, the High Line survives as a raised industrial reliquary, an urban nature path, a photographic subject and multivalent hope in a city where how the landscape looks and what it means can change in a New York minute.

ABELARDO MORELL, "CAMERA OBSCURA IMAGE OF BOSTON'S OLD CUSTOMS HOUSE IN HOTEL ROOM, 1999"
VERA LUTTER, "333 NORTH MICHIGAN AVENUE, CHICAGO, IL: OCTOBER 16, 2001"

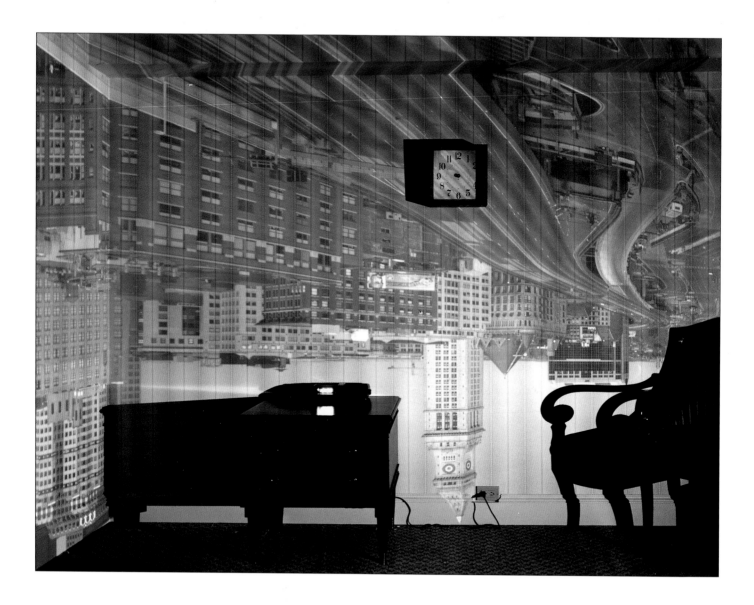

CONFLATING DIRECT AND INDIRECT EXPERIENCE, MORELL BRINGS THE CITY AND THE VIEWER INSIDE
THE CAMERA, WHICH IS A STODGY HOTEL ROOM. LUTTER BUILDS ROOM-SIZE CAMERA OBSCURAS
AND IS OFTEN INSIDE THEM DURING THE EXPOSURES, WHICH CAN LAST HOURS, DAYS, OR WEEKS.

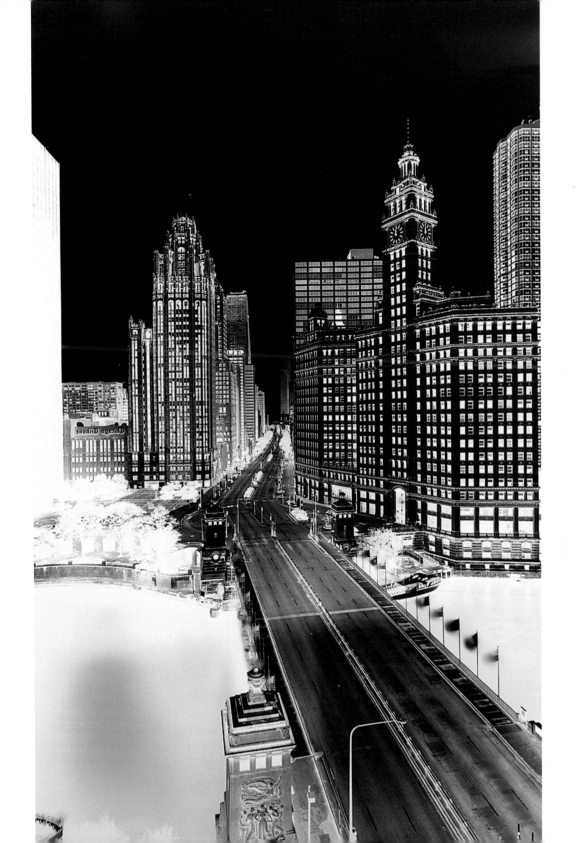

HAVANA AS ECHOING EMPTINESS. PAGLIARI ATTEMPTS TO "COME CLOSER TO THE WORLD, NOT TO ITS PICTORIAL
REPRESENTATION, BUT TO ITS UNKNOWN AND INVISIBLE ELEMENTS." THE PROSAIC ACTIVITIES OF PEACE IN HANOI CONTRAST
IN LE'S PHOTO WITH THE ANGER, FEAR, AND BUNKER MENTALITY THAT GRIPPED THE CITY DURING THE VIETNAM WAR.

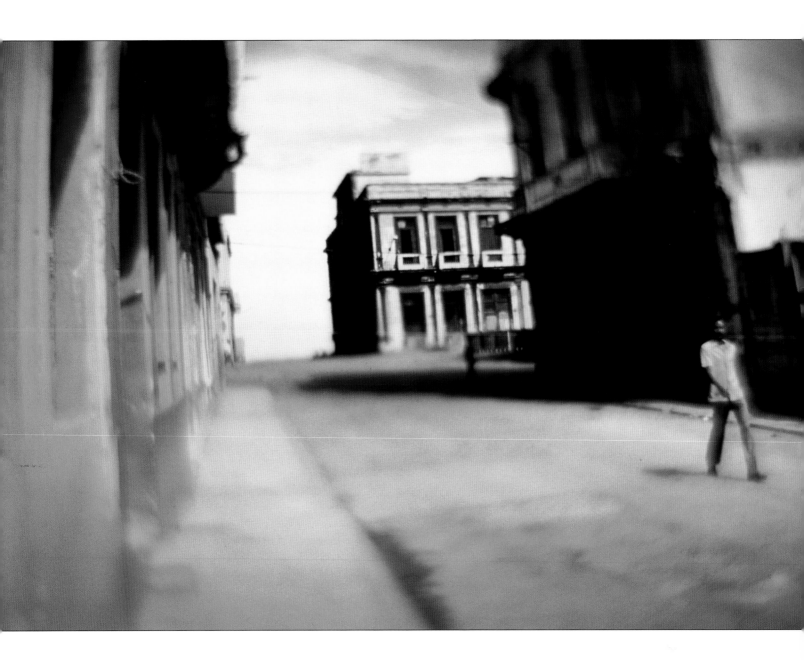

DAVID ALAN HARVEY, "VIA TOLEDO," 1998
STEPHEN HOBBS, "URBAN ANTINARRATIVE #22," 2002

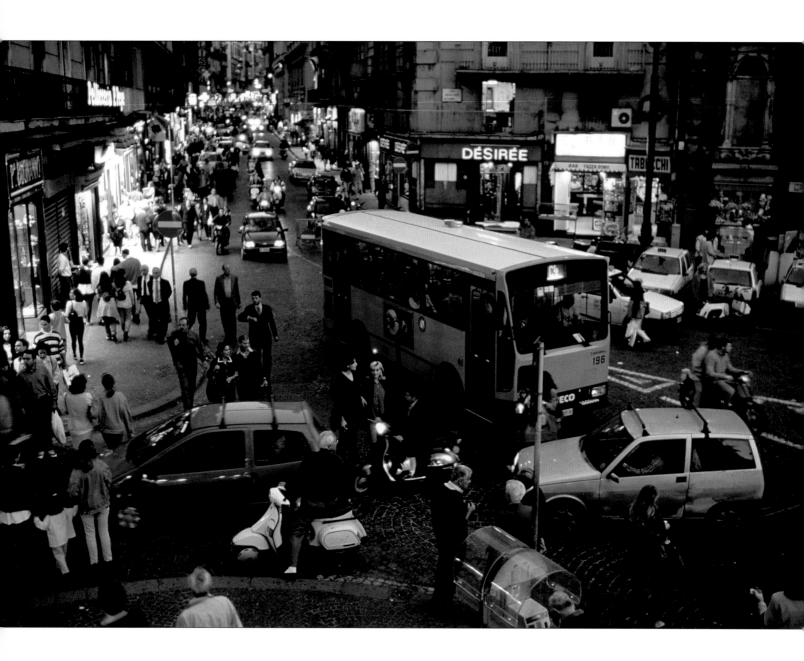

STREET LIFE TAKES CENTER STAGE IN HARVEY'S PICTURE OF NAPLES'S RUSH HOUR, WHERE ORDER SEEMS TO COME FROM BODY LANGUAGE RATHER THAN GOVERNMENTAL AUTHORITY. HOBBS TAKES A SOCIOLOGICAL APPROACH TO PHOTOGRAPHING JOHANNESBURG'S TRANSITION FROM CITY CLOSED TO BLACKS BY APARTHEID TO AFRICAN METROPOLIS.

SEBASTIÃO SALGADO, "ACROSS THE RIVER LOOMS THE MODERN FINANCIAL DISTRICT OF PUDONG, WITH THE ORIENTAL PEARL TV TOWER IN THE FOREGROUND AND THE GRAND HYATT HOTEL TO THE RIGHT. SHANGHAI, CHINA, 1998"

SEBASTIÃO SALGADO, "PEASANTS WHO USED TO SIT ON THE WINDOW LEDGES OF THEIR RURAL HOMES CONTINUE TO DO SO IN CROWDED APARTMENT BUILDINGS. HO CHI MINH CITY, VIETNAM, 1995"

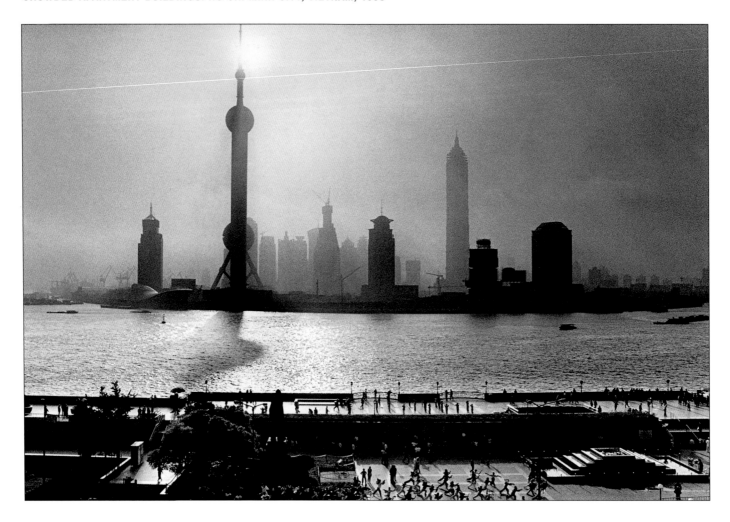

SALGADO'S "LEAVING THE LAND FOR THE CITIES" SERIES EXAMINES MIGRATION THROUGHOUT THE WORLD. TACKLING ONE OF THE MOST SIGNIFICANT TRANSFORMATIONS IN HUMAN HISTORY AS IT WAS HAPPENING WAS A DAUNTING TASK. SALGADO ACCOMPLISHED IT BY TAKING PICTURES THAT STAND BY THEMSELVES BUT ALSO COMMUNICATE CLEARLY AND DIRECTLY WITH EACH OTHER, FORMING A UNIVERSAL NARRATIVE.

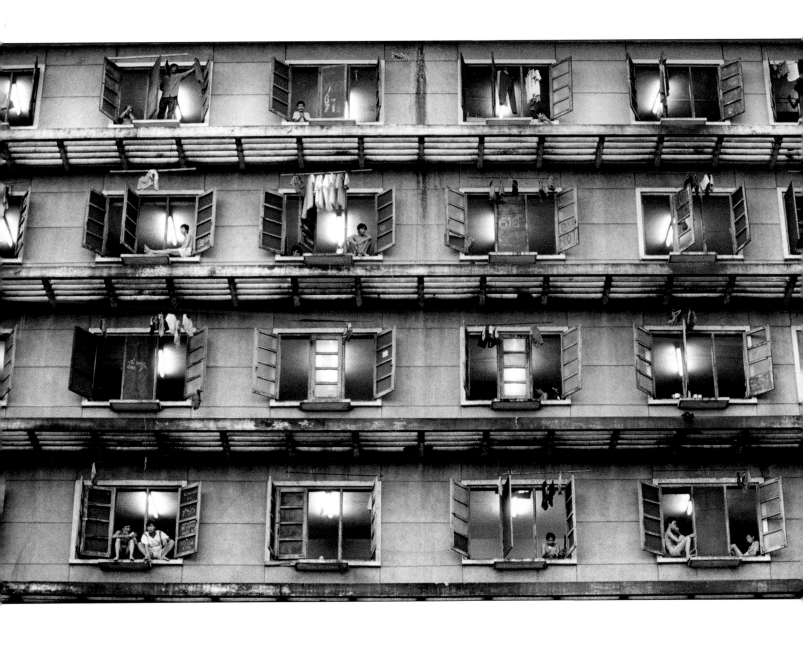

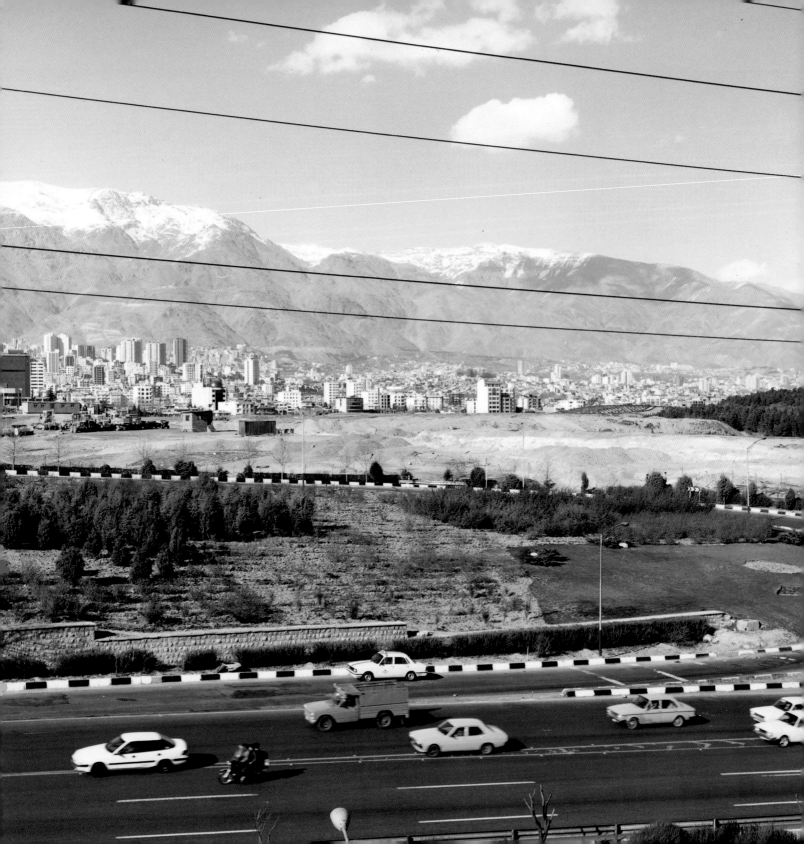

VEHICLES ZIP ALONG THE FREEWAY IN SHAHBAZI'S PHOTO OF DAILY NORMALCY
IN THE IRANIAN CAPITAL. THIS SPRAWLING, BUSY METROPOLIS COULD BE A CITY
IN THE WESTERN UNITED STATES, NESTLING AGAINST THE ROCKY MOUNTAINS,
RATHER THAN THE HOMETOWN OF THE ISLAMIC REVOLUTION.

OLA KOLEHMAINEN, "TOUR FINANCES," 2002
WOLFGANG TILLMANS, "PALISADES"

"IT HAS BEEN SAID THAT NUTRITION IS THE FIRST EXPRESSION OF CULTURE. THE SECOND ONE IS THAT SPACE THAT SURROUNDS US:
ITS FUNCTION, AND SLIGHTLY LATER, ITS FORM," SAYS KOLEHMAINEN. IN TILLMANS'S PHOTO, THE L.A. PAVEMENT
IMPINGES ON THE PARK, MAKING IT SEEM LIKE AN URBAN STAGE WHERE ATOMIZED VIGNETTES OF CITY LIFE PLAY AT ALL HOURS.

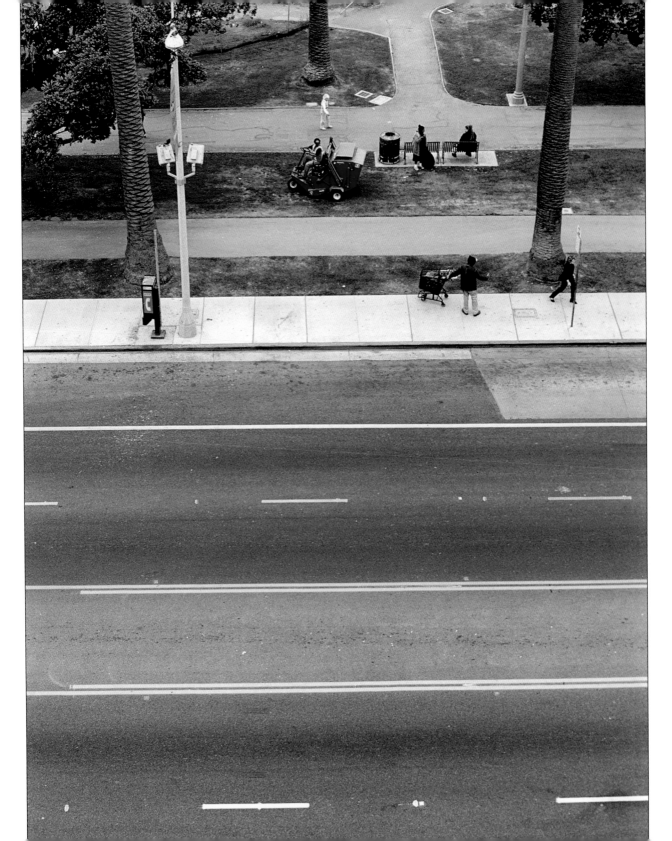

SAM ABELL, "VENDING MACHINE," HAGI, JAPAN, 1980
JOEL STERNFELD, "LOOKING EAST ON 30TH STREET ON A MORNING IN MAY," 2000

A VENDING MACHINE IN JAPAN APPEARS TO BE SELLING LANDSCAPE FROM THE WESTERN UNITED STATES. TAKE SOME HOME AND YOU, TOO, CAN DRIVE TO FREEDOM. THE HIGH LINE IN MANHATTAN WAS BUILT IN THE 1930S AS AN ELEVATED FREIGHT RAILWAY. AN ORGANIZATION CALLED "FRIENDS OF THE HIGH LINE" IS WORKING TO TURN IT INTO A GRAND PUBLIC PROMENADE.

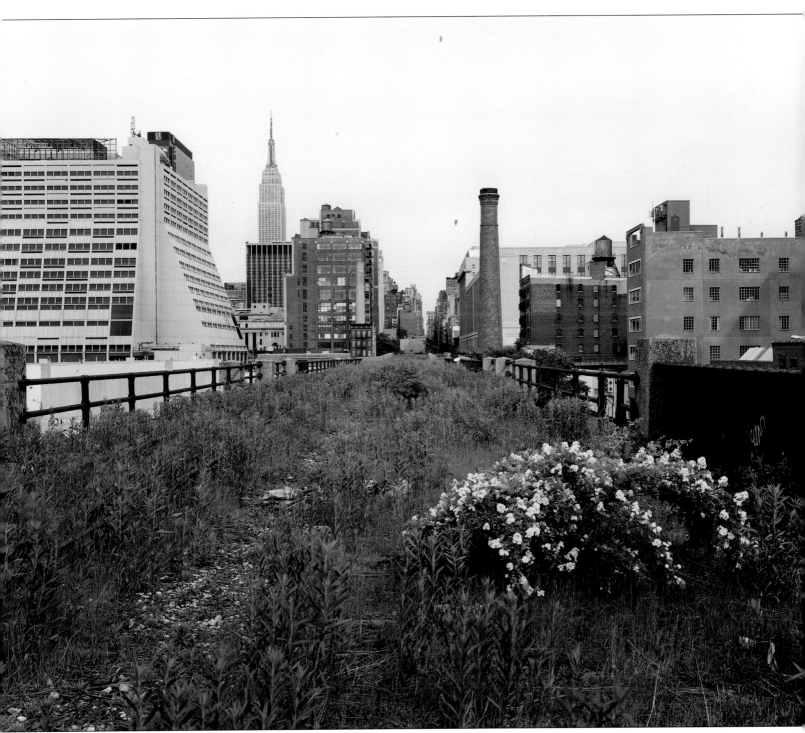

SOCIOPOLITICAL LANDSCAPE

TO SUBSTANTIATE MY CENTRAL ILLINOIS ARCADIA, I DID WHAT LANDSCAPE PHOTOGRAPHERS HAVE DONE since the camera was invented. I traveled to a sociopolitical construct and took its picture.

The prairie I photographed is part of the Rock Springs Center, a nature preserve run by a local governmental body. My pure, unfettered nature, the antithesis of Germany's crowded cities, groomed hiking paths, and tidy forests, had been carefully manipulated for the common good long before I tried to couple its evocative power to my psychological agenda.

Just as there are no landscape photographs without people, there are none devoid of sociopolitical content or context. Even paradise, arcadia, or whatever name one applies to the conceptual epicenter of most landscape art, as well as myriad belief systems, can be seen in sociopolitical terms as a perfectly managed microcosm, a changeless, timeless ecosystem where pristine nature fulfills all human wants and needs.

That notion of natural, even divine, perfection inspired Henry David Thoreau's assertion that "in wilderness lies the preservation of the world." At the start of the 21st century, however, his claim has been forcefully amended by the duplicity of politics and social mores, which have permitted the wholesale destruction of the world's wild places while preserving what wilderness remains.

As we have seen, religion, government, philosophy, and commerce were influencing depictions of

JORMA PURANEN, "TABULA MODERNA GEOGRAPHIA"
JORMA PURANEN UNDERSTANDS LANDSCAPE AS A SERIES OF DIFFERENT CULTURAL SPACES. "IT'S A PLACE OF INTERACTION, NOT CONTEMPLATION, A PLACE LYING BETWEEN OUR VERBAL DESCRIPTION AND VISUAL EXPERIENCE."

landscape even before it became an independent genre of art. They continued to do so when it moved from the background to center stage. The development and exponential growth of photography and photomechanical reproduction have only amplified their reach and effects.

Besides physically controlling the landscape, political and social forces often employ it as a photo model to promote their agendas. William Henry Jackson's photos of Yellowstone were instrumental in establishing a system of national parks in the United States. Pictures of the Rocky Mountains or Japan's Mount Fuji are viewed as enduring symbols of national identity and pride despite the pollution fouling the mountains' air and the development lapping at their slopes. Photographs of unsullied landscapes are used as calendar cheesecake—displaying a metaphorical counterpoint to the urban and industrial areas seen as despoiled by human actions—by nongovernmental organizations such as the Sierra Club to garner funds and followers.

How and why social and political forces inform or appear in contemporary landscape photographs depends mainly on the artists: who they are; where they live and work; their creative visions. The photographers in this chapter use photography to scrutinize the relationship between landscape in its broadest sense and social, economic, and political forces such as racism,

sexism, poverty, pollution, and violence. Their pictures share a hauntingly plain beauty that bears eloquent witness to the physical and emotional scars human beings inflict on the Earth and each other in the name of social and political policy.

In realizing their personal visions, some of the artists overtly manipulate their pictures by placing objects, actors, or themselves in the landscape. In the late 1990s, Jorma Puranen created a body of work using pieces of silk on which Latin phrases were silk-screened. These he placed and photographed in Nordic landscapes altered by industrial activity.

The silk banners make his photo of flat-topped piles of mine tailings in "Tabula Moderna Geographia" look like an illustration from famed Swedish taxonomist Carolus Linnaeus's *System Naturae*, published in 1735, which first established his system for naming, ranking, and classifying organisms that is still widely used today. By juxtaposing the fabric bearing an archaic language and the harsh aftereffects of mining, Puranen calls attention not just to the history of exploration and exploitation of the landscape but to the space that exists between what we see in the world and how we describe it using language. What one culture calls terra incognita, for example, another might call home.

In sociopolitical terms, landscape art is also a space dividing the world's wealthy societies from its poor. Art,

landscape included, is not egalitarian. It is the province of educated, affluent people who can afford to make, appreciate, and traffic in it. Finding photographs of the African landscape by non-Africans is easy. Finding contemporary landscape photography of Africa by Africans is quite difficult because the artists living in many of that continent's countries cannot afford or do not have access to basic photographic supplies.

The enormous divide between Africa as photo spread in glossy, international magazines and as a place where people actually live echoes in "Ici et Maintenant," a photograph of an installation in Joal-Fadiouth, Senegal, by Vanessa Van Obberghen, a Belgian artist, working in collaboration with Huit Facettes, an eight-man Senegalese artists' collective. The photo by Amadou Kane Sy, a Huit Facettes member, features the shell of a TV stuck on a post, framing skinny white cattle grazing under the fierce sun. This isn't the interface of man and pure nature that inspired Edmund Burke or the cinematic Africa of films and television. It's reality. Photography, television, videos, and computers are beyond the reach of much of Senegal's population, which lives in direct contact with the land, struggling to survive.

Survival seems a faint hope when one gazes into the black-hole shadow at the center of Emmet Gowin's "Sedan Crater, Northern End of Yucca Flat, Nevada Test Site." From an airplane, the subsidence crater caused by an underground atomic bomb test becomes a study of texture, tone, light, and shadow in a place where the Earth's skin has the sere, alien beauty of the lunar landscape. The crater also resembles an inoculation scar, as if society had injected itself with a potentially lethal pathogen in hopes of saving humanity from destroying itself.

Geoffrey James's "Vimy Ridge, Quebec" documents the open-pit mining of asbestos in Quebec and the dumping of the mining's by-product in the surrounding countryside. The scarring of the land is obvious and severe. Yet James finds an alluring paradox, the classically beautiful form and texture of a seashell, in the waste heap. The substance being mined is also paradoxical in nature, asbestos being an effective fire retardant whose fibers are also highly carcinogenic.

A great arc of flame lights the landscape in a scene from the desert funeral ritual in *Passage,* a film by Shirin Neshat, whose work examines the status of women in Islam and gender and identity issues in her native Iran. As a child observes from behind a cairn, women in black chadors dig a shallow grave with their hands and a column of men stand at a distance beside the corpse. That separation is ambiguous. One moment it seems vast and insurmountable, the next, a mere interlude before contact and communication resume. The symbolism of the funeral is also unclear. It could be for the freedom of women in repressive cultures or the Persian identity in

Iran being supplanted by Arab nationalism. But the fire suggests catharsis and the child in the foreground offers hope for a better future.

In "Shopping Cart in Ice," Frank Day found radiance and spirituality in the detritus underneath a bridge on Interstate 95, the main north-south freeway on the United States' eastern seaboard. Trapped by an abandoned shopping cart beneath an overpass in Baltimore harbor, a plastic bag resembles an angel, either bowed in prayer or lifting its face to heaven. The vertical shadows lend a cathedral air to the eerily beautiful scene, evoking Rainer Maria Rilke's lines from his *Duino Elegies:* "for beauty is nothing / but the beginning of terror, which we still are just able to endure, / and we are so awed because it serenely disdains / to annihilate us. Every angel terrifying."

Terror gives way to renewal in Robert and Shana ParkeHarrison's photographs, such as "Cloud Cleaner," and "Earth Coat." Their scenes are staged and feature Robert, in a dark suit, playing an odd Chaplinesque fellow tackling the monumental tasks of cleaning up the environment with basic tools. If Woody Allen and Alvin Langdon Coburn had collaborated on landscape photographs, they might have looked like the ParkeHarrisons' work. Beyond the surface humor, their landscapes speak directly to humanity's most basic myths: how the world was created, how nature evolved, and how human beings fit in the picture.

There are no human beings, no geologic features, and no horizon in Edward Burtynsky's "Densified Oil Filters," just an expanse of crushed oil filters. It's a big photograph, with the topography and layered detail of a Jackson Pollock painting. The filters imply the engines they served and by extension the vehicles, making them a condensed metaphor for North America's love of cars and driving, its automotive industry, and the millions of miles of road through every imaginable landscape that the filters have traveled. Burtynsky takes viewers into the middle of the pile, then leaves them to decide whether they are in automotive purgatory or photographic heaven.

Without its title, Santu Mofokeng's photograph "Courtyard for Political Prisoners, Robben Island," would be similarly ambiguous. On its surface, the picture is a quiet study of form, texture, and space. But what if this banal courtyard was your entire experience of the outdoors for years, as it was for Nelson Mandela and other leaders of the African National Congress, who were imprisoned there for decades during apartheid? Does the landscape's meaning change along with the political context?

"The demise of apartheid in South Africa, relatively recent, poses a challenge for the people there," Mofokeng wrote. "The dilemma is how to deal with the memory of the past. For instance: Who owns this memory? What is re-memoried (re-remembered) and how?

How long is the memory? What do we do with the memory? Do we need this memory? Who can be trusted with this memory?"

South Africa's past and present collide in David Goldblatt's photograph "Braamfontein from Newtown 01.11.01." The new South Africa created by Mandela and others is free of apartheid, but not immune to the social dislocations—poverty, disease, trash, and poor people flocking to the cities from the countryside—that plague much of the world. Goldblatt's photo brings out the dump's visual vibrance, the jumble of bright colors and odd shapes. More important, it highlights the tectonic nature of social change. There's no balletic decisive moment, no pas de deux of light and shadow, nothing Stieglitz or Cartier-Bresson could look at and say, "Ah, that's art." Instead there's a feeling of social forces—power, money, race—pushing against each other along the fault line of everyday life, in rough equilibrium but with the potential for cataclysm.

In June 1968, Paul Fusco photographed the aftermath of a social cataclysm, when he rode the funeral train carrying the body of Senator Robert F. Kennedy, who was assassinated while running for the Presidency, from New York City to Washington D.C. The trip, which normally lasted about four hours, took twice as long because of the crowds lining the tracks to catch a glimpse of Kennedy's coffin.

Fusco didn't set out to create art when he boarded the train. But his senses, sensibility, and skills conspired with time and place to produce a body of work containing almost all the ideas—the personal and conceptual approach, abstraction, minimalism, color fields, soft focus, skewed viewpoints, people in the picture—that have shaped contemporary photography in general and the landscape genre in particular over the past 30 years.

He did this by photographing people the train passed: black, white, city dwellers, suburbanites, and country folk. Old people sitting in lawn chairs. Young adults perched on motorcycles. Kids on parents' shoulders peering over the crowded platform of an urban station. People in their work clothes, people sporting their Sunday best. Some are crying, some hold signs, others just stare, a few smile or laugh.

No one knows exactly how many there were; estimates range to one million. Whatever the number, for one day they were America, a transient landscape of flesh and blood, a people become a place riven by sorrow for a murdered leader being carried home on the last train out of Camelot.

HUIT FACETTES, "ICI ET MAINTENANT" JOAL-FADIOUTH, SENEGAL, 1998,
INSTALLATION BY VANESSA VAN OBBERGHEN

HUIT FACETTES © AMADOU KANE SY

THE SOCIOPOLITICAL REALITY BEHIND AFRICA'S CINEMATIC BEAUTY. FOR PEOPLE
STRUGGLING TO MEET BASIC NEEDS FOR FOOD, CLOTHING, SHELTER, AND MEDICAL
CARE, THE LANDSCAPE'S AESTHETIC APPEAL, FRAMED BY A TV'S SHELL, MATTERS
FAR LESS THAN WHAT IT CAN PROVIDE TO SUSTAIN THEIR LIVES.

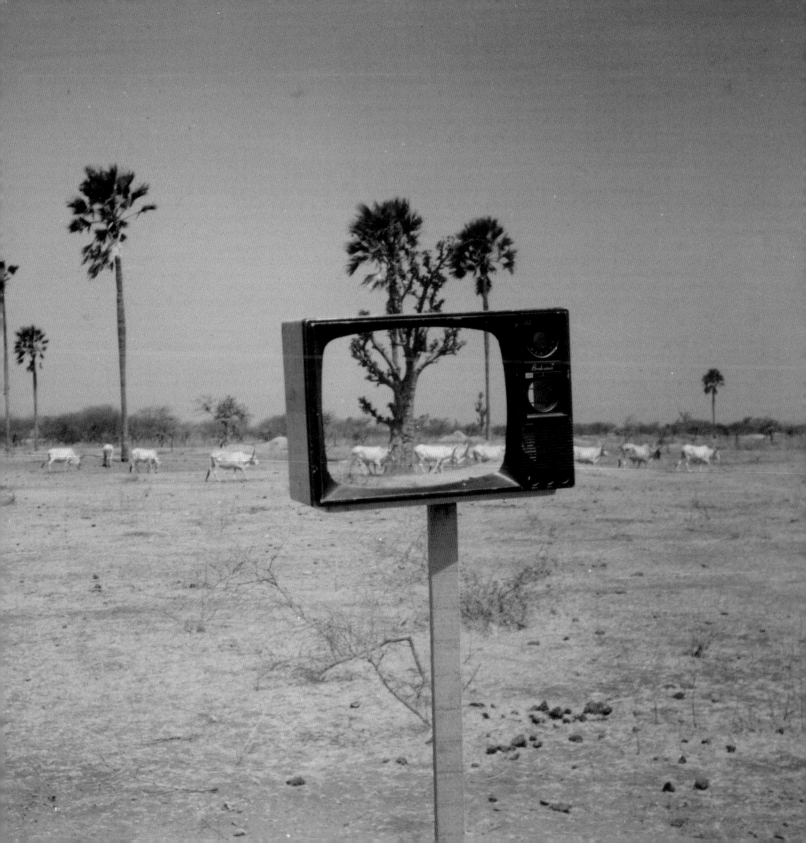

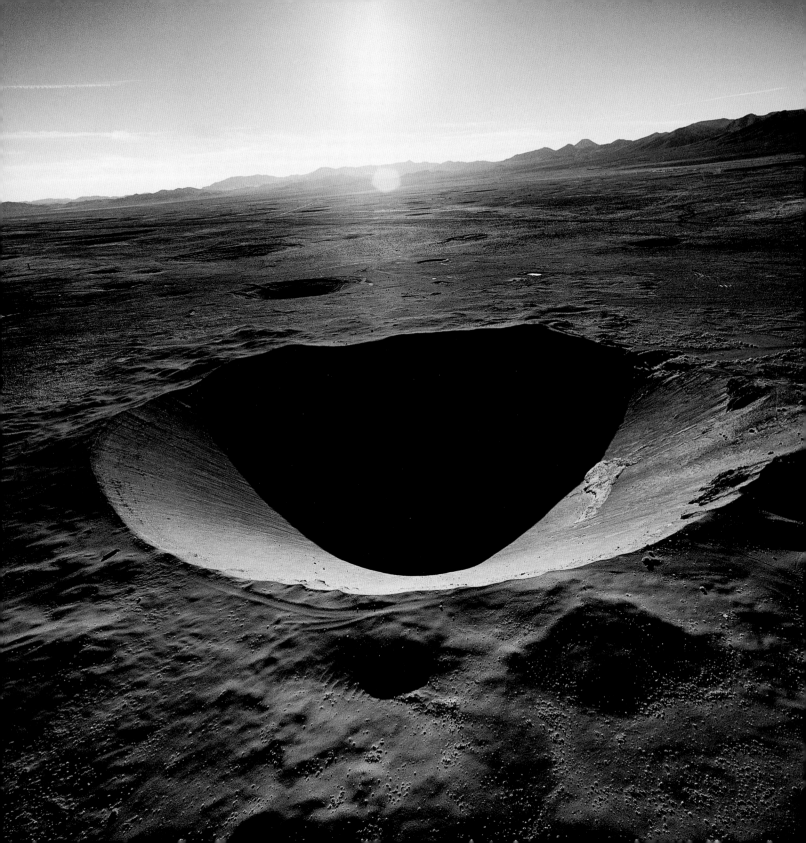

EMMET GOWIN, "SEDAN CRATER, NORTHERN END OF YUCCA FLAT, NEVADA TEST SITE," 1996

GEOFFREY JAMES, "VIMY RIDGE, QUEBEC," 1993

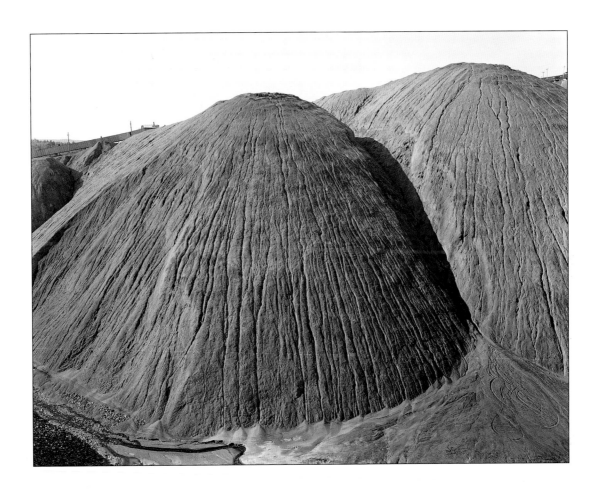

GOWIN FINDS BEAUTY IN THE SCARS HUMANS MAKE ON THE EARTH. FROM ABOVE, THE NUCLEAR BOMB TEST CRATER LOOKS LIKE THE ENTRANCE TO HADES. JAMES'S PHOTOS OF OPEN-PIT ASBESTOS MINING IN QUEBEC"...EXPLORE THE COLLAPSE, OR NEAR-DISAPPEARANCE, OR SHIFT IN MEANING, OR, IN CERTAIN CASES, THE MIRACULOUS PERSISTENCE OF VARIOUS IDEAL OR UTOPIAN SPACES."

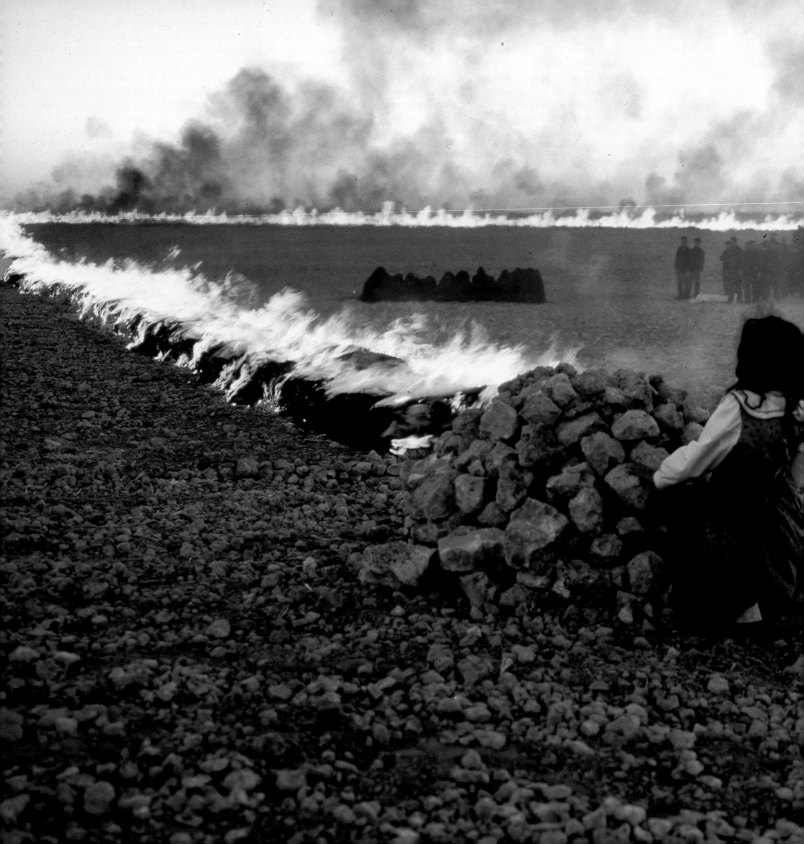

SHIRIN NESHAT, "PASSAGE," 2001
PHOTO TAKEN BY LARRY BARNS. COURTESY BARBARA GLADSTONE

NESHAT SAYS THE ISLAMIC IDEOLOGY THAT HAS BEEN GROWING RAPIDLY IN THE
MIDDLE EAST IS SEEN IN THE WEST AS A THREAT. "IT'S NOT EVEN A RELIGION.
IT'S LIKE THE SOVIET UNION, COMMUNISM, WHICH WAS ONCE A THREAT. I THINK
THAT ISLAM IS VERY OFTEN DISMISSED BECAUSE THAT IDEOLOGY DOESN'T FIT
INTO THE KIND OF RATIONALITY THAT THE WESTERN WORLD HAS."

FRANK DAY, "SHOPPING CART IN ICE," 2001

DAY BECAME ENCHANTED WITH THE CORRUPTED AND POLLUTED BEAUTY HE FOUND BENEATH THE OVERPASSES OF I-95, THE MAIN NORTH-SOUTH FREEWAY ON THE EASTERN SEABOARD OF THE UNITED STATES. "THEY ARE AN ALLEGORY FOR A WAY OF BEING IN THE WORLD," HE SAYS.

ROBERT AND SHANA PARKEHARRISON, "CLOUD CLEANER"
ROBERT AND SHANA PARKEHARRISON, "EARTH COAT"

"I LOVE TO TRY TO CAPTURE THAT QUALITY OF THE EARTH LOOKING LIKE THE WORLD'S JUST STARTED OR BEEN DESTROYED AND IS STARTING ALL OVER AGAIN—THAT FEELING OF BEING WAY BACK IN THE PAST OR WAY AHEAD IN THE FUTURE."–ROBERT PARKEHARRISON

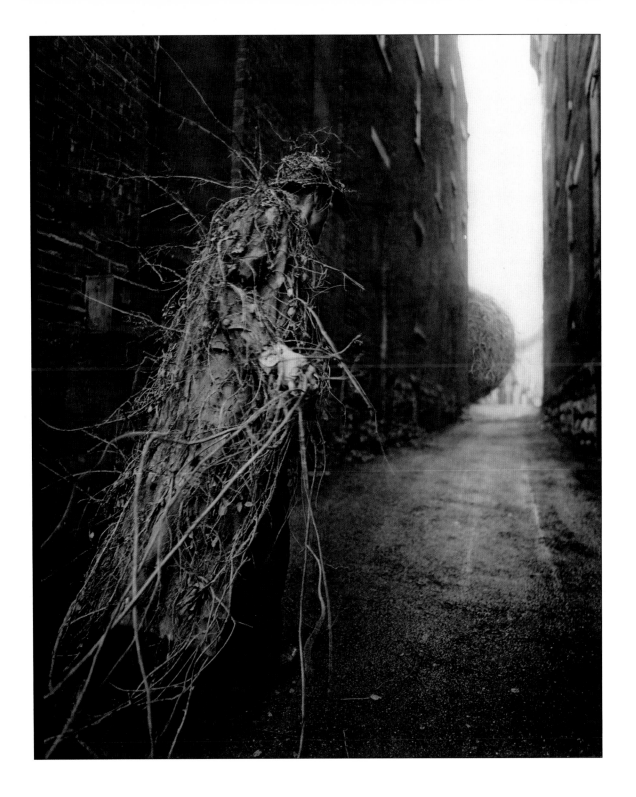

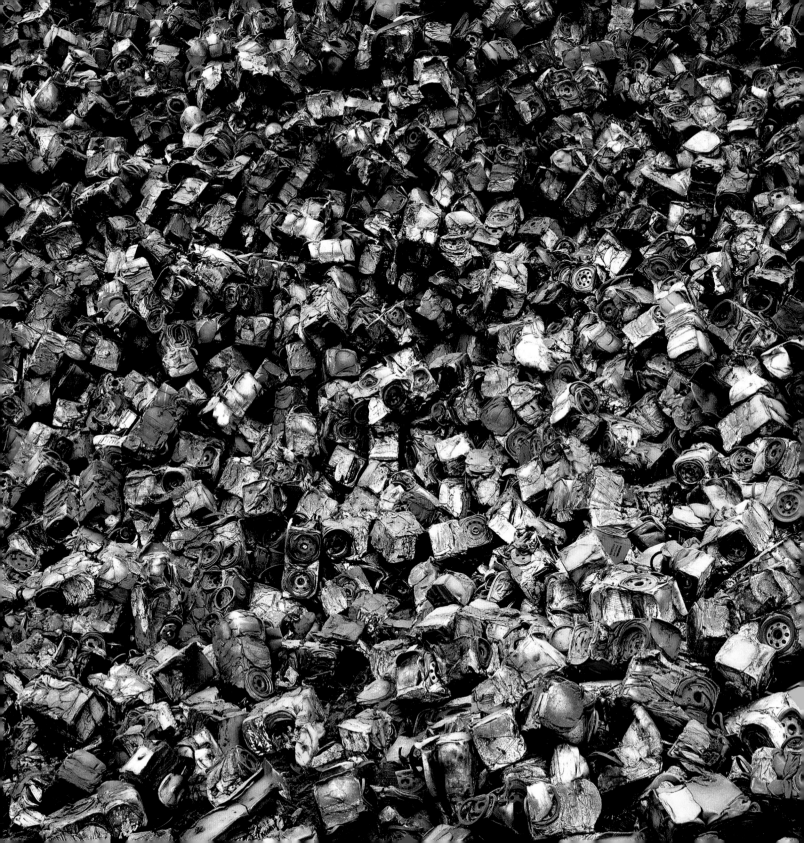

"THE INDUSTRIAL LANDSCAPE SPEAKS TO OUR TIMES," BURTYNSKY SAYS. "I SEE MY WORK AS BEING OPEN TO MULTIPLE READINGS. ONE CAN LOOK AT THESE IMAGES AS MAKING POLITICAL STATEMENTS ABOUT THE ENVIRONMENT, BUT THEY ALSO CELEBRATE THE ACHIEVEMENTS OF ENGINEERING OR THE WONDERS OF GEOLOGY."

SANTU MOFOKENG, "COURTYARD FOR POLITICAL PRISONERS, ROBBEN ISLAND," 2002
DAVID GOLDBLATT, "BRAAMFONTEIN FROM NEWTOWN 01.11.01," FROM THE SERIES "JO'BURG INTERSECTIONS," 1999-2000

© SANTU MOFOKENG—SOUTH PHOTOGRAPHS

LANDSCAPES ARE OFTEN FREIGHTED WITH INDIVIDUAL AND COLLECTIVE MEMORIES. THE BANAL COURTYARD IN MOFOKENG'S PHOTO CAN ALSO BE SEEN AS A BATTLEFIELD WHERE APARTHEID WAS DEFEATED. THE NEW SOUTH AFRICA ISN'T PARADISE, AS GOLDBLATT SHOWS. DURING HIS CAREER, HE HAS BEEN DRAWN "TO THE QUIET AND COMMONPLACE, WHERE NOTHING 'HAPPENED,' AND YET ALL WAS CONTAINED AND IMMANENT."

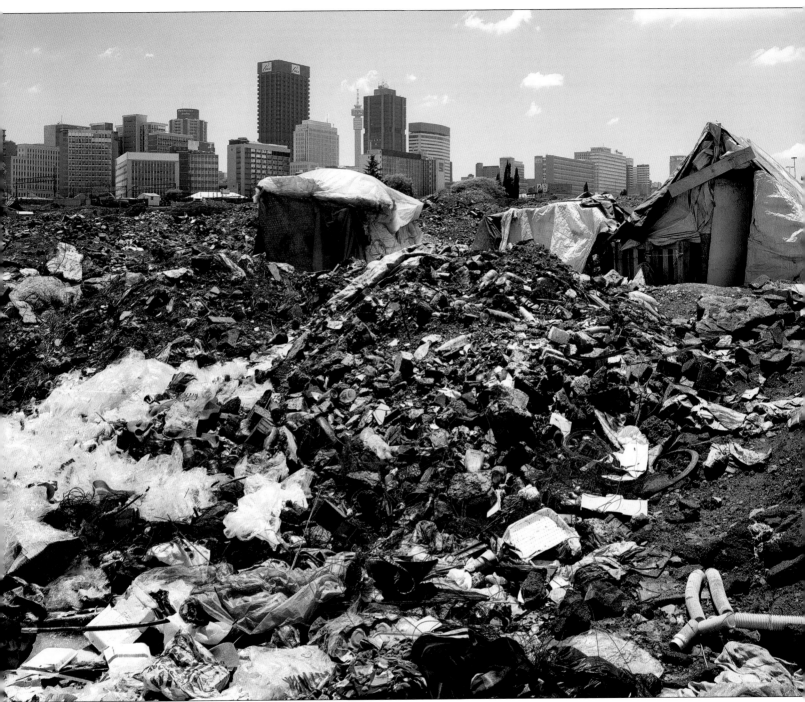

PAUL FUSCO, "ROBERT KENNEDY FUNERAL TRAIN," 1968

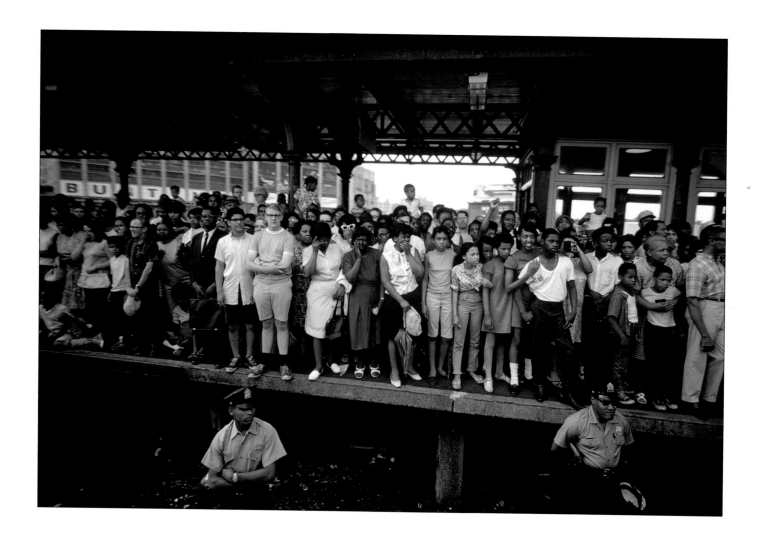

IN THE END, "...HE BECAME HIS ADMIRERS," AS W. H. AUDEN WROTE IN HIS POEM EULOGIZING WILLIAM BUTLER YEATS.
IN PAUL FUSCO'S PHOTOS TAKEN FROM THE TRAIN CARRYING BOBBY KENNEDY'S BODY FROM NEW YORK TO WASHINGTON,
PEOPLE AND PLACE BECAME, FOR A FEW HOURS, ONE ENTITY, A BEAUTIFUL VESSEL FILLED WITH SORROW.

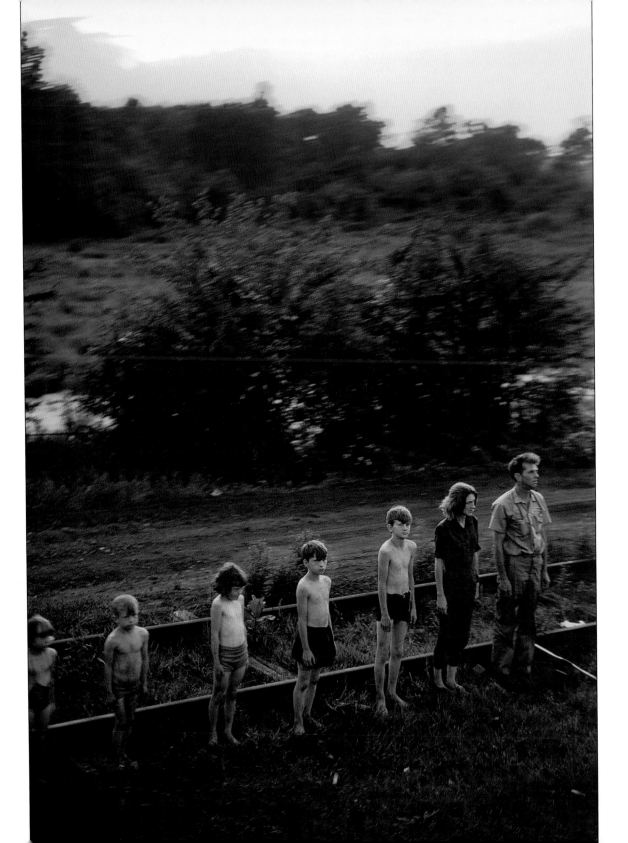

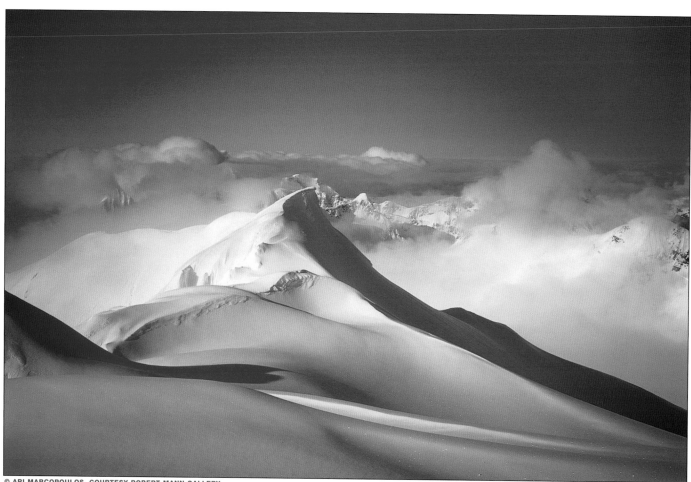

SIMPLY PRESERVING PARADISE

THE IDEA OF THE WORLD'S PRESERVATION LYING IN WILDERNESS, PRESENTED BY THOREAU IN HIS 1862 ESSAY "Walking," has universal appeal but limited applicability. Thoreau, as many of us do, wanted to preserve a specific world—his time and place—as he experienced it: the Massachusetts woodlands as transcendental refuge, muse, meal ticket, and portal to the divine.

Even as Thoreau praised wilderness, his personal paradise's wild days were fast becoming myth and memory. What his woods still possessed was location, a quality universally prized in real estate. Walden Pond was far enough from family, friends, and the nearest village that Henry could ponder, write, and nature-trip uninterrupted, yet not so distant as to completely sever contact with his relations, admirers, and publishers.

My Illinois arcadia came with similar caveats. It was a managed approximation of wild tallgrass prairie, far enough from town to feel removed from daily life, but close enough for convenient picture taking.

Wild or domesticated, New England or New South Wales, the way most of us preserve the world we encounter outdoors is by photographing it. With care and luck, our preserved images will closely resemble their source and perhaps survive their maker. But the three central elements of landscape photography—

ARI MARCOPOULOS, "JUNEAU, ALASKA, 1999"
A LANDSCAPE PHOTO'S MEANING DEPENDS MAINLY ON THE VIEWER. MARCOPOULOS SHOT THIS VISION OF PRISTINE ALASKAN NATURE FROM A HELICOPTER IN WHICH PROFESSIONAL SNOWBOARDERS WERE PLOTTING DESCENTS. SO IS IT ART FOR CONSERVATIONISTS, ADRENALINE JUNKIES, OR EVERYONE?

time, place, and people—cannot be fixed forever. Turned into photos, they become, to borrow a phrase from the poet Weldon Kees, "like spines of air, frozen in an ice cube." Sooner or later, pictures and people will melt into nothingness.

Even the photos that survive may not be appreciated or understood as the photographer wished. Viewers, individually and collectively, apply their own set of aesthetic, social, and political values to them. Photographs can be literal and verisimilar or dissembling, but since we are all subjective beings, their meaning is never precisely transmittable.

The photographs of Ari Marcopoulos are a case in point. His "Juneau, Alaska, 1999" is a mountain scene so beautiful, unspoiled, and blue heavenly it looks like a Technicolor Ansel Adams. But seeking out and photographing gorgeous landscape wasn't Marcopoulos's goal. Documenting the subculture of professional snowboarders was. The picture was taken from a helicopter in which the snowboarders were scouting out lines to ride down the mountain. For the athletes, that image of pristine powder is about finding a descent, plotting an adrenaline rush through their paradise.

Just by looking at the photo, most viewers could not deduce that. Nor do they need to in order to have an intellectual or emotional response. When Marcopoulos's

pictures are exhibited in galleries and museums or featured in books, language provides the cultural context. Even then, viewers see in the work what they will. No artist can prevent that. If Marcopoulos leaned too heavily on language to explain his picture, its magic would be lost, its art-rush diminished.

The magic of Japan's aesthetic tradition emanates from Michael Kenna's "Frozen Landscape, Teshikaga, Hokkaido, Japan." The sky, snow, lone tree, and wire fences are brushy and lyrical, like a calligraphic painting on rice paper. The fence posts marching to the distant horizon add a Christo touch. The empty expanse is in stark contrast to the mass-media image of Japan as a sardine can packed with people and pricey real estate. Traveling through the hectic Japanese present, Kenna turned to the countryside and found space and the meditative beauty of Zen.

A similar sense of the physical world expanding into the imaginary and spiritual realm is evoked by an Alpine lake in Hiroshi Sugimoto's "Boden Sea, Uttwil." Since 1980, Sugimoto has been shooting seascapes that combine Japanese aestheticism with minimalist and conceptual currents. As seen from its Swiss shore, the lake and sky form two gradated monochromatic fields, one dark, one light, which blur together at the horizon. The picture is not, however, a strictly formal study. The water in Sugimoto's seascapes is always recognizable as such,

opening allusions to water being the source of all life and to the hypnotic, contemplative space the ocean offers.

The space in "Poplar Plantation, Dundee 3 (detail)," by Sophy Rickett, is compressed, not expansive. A lone, leafless tree, vigorous and handsome enough to audition for a Caspar David Friedrich painting, stands braced against the elements. That romantic notion quickly vanishes, however, because the sapling and the foreground radiate a metallic yellow sheen, caused by sodium vapor lighting. The black night sky, flat as a Byzantine background, amplifies the eerie color and feeling of isolation, making the tree and its setting seem artificial. There is no narrative or allegory here, just Rickett using photography to produce a rigorous study of perspective, light, space, and the artificiality of color as it appears in photographs.

Christopher Burkett, on the other hand, tries to make the photographic process disappear in pictures such as "Pink and White Dogwoods." Unlike Marcopoulos, finding beauty in the world and photographing it is his intent. "The beauty and grace, which you may glimpse from time to time in my photographs, is not something which I manufactured, manipulated, or created," Burkett says. "My task is to simply present this reality in the clearest, most luminous, and direct way with the least amount of distraction from myself or the photographic process." That approach produces unabashedly spiritual pictures celebrating the miraculous convergence of light, shapes, and colors that only nature commands.

Man does the commanding in Ilkka Halso's series of photographs titled "Restorations." The underlying concept is that nature has fallen into disrepair and must be renovated. To that end, Halso builds elaborate, artificially lit scaffolds to support and repair trees, rocks, and sunflowers. The irony of these part-installations, part-photos is that to restore nature to its natural state and undo the damage caused by modern industrial society, human beings turn to the same technologies that caused the problems in the first place. Nature's chaotic order succumbs to the scaffolds' modular geometry. Halso presents those ideas in carefully composed photos of rich, almost otherworldly color, giving his humor dignity, depth, and an edge.

Finding a contemporary edge in the Dutch landscape means escaping some giant art-historical shadows. Besides providing the etymon of the word, Holland was a citadel of landscape painting, home to Jacob van Ruisdael, Jan van Goyen, Albert Cuyp, and others. Gerco de Ruijter literally rises above those 17th-century greats by attaching his camera to a kite from which he photographs the landscape around Rotterdam. His untitled photographs from that perspective vary widely and seem to reference every stylistic trend in modern and postmodern art. In the picture presented here, the Dutch coast, long a painted cliché,

takes on strange topographical emphasis, looking like fraying shag carpeting bordering a glassy Impressionist cloud scene.

Elger Esser became well known for his minimalist landscapes that paid homage through their colors and motifs to the paintings of van Goyen and other European masters. In recent years, his photographs have become even more personal and minimal. "Ameland Pier X, Netherlands" was taken on one of the Frisian Islands in northern Holland and emphasizes the flatness and linear character of the coastline. Sea and sky are both dishwater-white, joined at a pencil-line horizon. The dark lines of the eponymous pier run through the middle of the scene. Esser uses a low perspective that allows the viewer to contemplate his or her place in the shifting spatial relationships.

The viewer is inescapably part of Richard Misrach's "Road Blockade." The Pyramids are one of the world's wonders, depicted by artists since the days of pharaonic Egypt and a quintessential tourist cliché. That alone would cause many artists to pass on the subject. Misrach approached it head-on. He didn't pretend their awe-inspiring shape and size, their corroded surfaces, their postcard profile rising above the beautiful desert exist in a vacuum. The paved road snaking toward the Pyramids would connect them directly to our world were it not for the mysterious blockade of stones, which

restricts access to the big, beautiful picture, pulling the eyes back to the paved foreground, disrupting but not breaking the link between traditional and contemporary landscape photography.

Sheer picture size has helped German photographers such as Thomas Struth and Axel Hütte break down the barriers that once barred all photographs from the main exhibition halls of major art museums. But competing with paintings, which the large scale permits, subjects landscape photographs to some of the same strictures as their painted counterparts. The clarity and wealth of detail in big photographs can produce amazing depth of field or, as with some Struth landscapes, make them seem overly full, flat, and costive.

Hütte's landscapes, however, are often large but not overwhelming in size, and he employs detail with finesse. In "Hana, Maui" he seems to adhere to Edmund Burke's observation about painting that "judicious obscurity in some things contributes to the effect of the picture." None of the traditional elements of a landscape picture are present here. There is no horizon, no omniscient point of view, no vista, no earth, no sky, just a wall of fronds, beautiful in form and color, reaching toward the viewer. The plants represent nature's raw vigor. But the judicious obscurity of the deep shadows in the flora conjures up the dark side of paradise, suggesting that what nature conceals can be as important as what it

reveals. Where, after all, did the vices go after Minerva expelled them from the Garden of Virtue?

Measuring time is the critical element in Stephen Lawson's panoramic "The Year of the Drought," which documents one year's passage through the Virginia countryside. Lawson modified a camera to expose only a thin strip of film and developed a positioning system for making composite, collage-like panoramas. This technique enables him to extend the moment captured on film over long periods of time and a broad field of vision. There is odd grandeur in this pasture passing through months of drought. The strips fracture the space and time, but the landscape image flows together seamlessly and has the placid emotional resonance of a Paulus Potter painting of cows grazing in some Dutch meadow.

Odd but grand also applies to Wolfgang Tillmans's deceptively simple "Shaker Rainbow." For the Shakers, the American variant of England's "Shaking Quakers," perfecting the world meant chastity, morality, and equality for all. "Mother" Ann Lee, the group's founder, established utopian religious communities in the eastern and midwestern United States where communal living, simplicity, thrift, meditation, and abstaining from sexual relations were the rule. In its heyday, the Shaker movement had thousands of followers, inventive, industrious folk who pioneered form-follows-function design and

aesthetics. The Shakers wanted to transform the world into utopia, not preserve it as wilderness. They failed.

Tillmans's photograph is an allegory for their quixotic quest to control human nature, to balance yin and yang and achieve perfection. The austere Shaker house, with its double doors so men and women could enter separately, has a spiritual glow. But the perspective Tillmans chose makes it seem in danger of sinking into the black hole of the foreground. The setting sun has mottled the white clapboard with a tree shadow, another skirmish in the eternal battle between light and darkness. Above it all, though, a double rainbow lights the sky, a simple gift, to paraphrase the title of a Shaker hymn: "'Tis the gift to be simple / 'Tis the gift to be free/ 'Tis the gift to come down where we ought to be / And when we find ourselves in the place just right / It will be in the valley of love and delight."

Finding that right place, perfecting or preserving even small chunks of paradise, is a consuming task. We chase rainbows for the riches and overlook the gifts of simple beauty waiting at their end, like a Shaker village, freshly showered by a summer storm, ready to welcome saints or sinners to a picture-perfect world, if only for a moment.

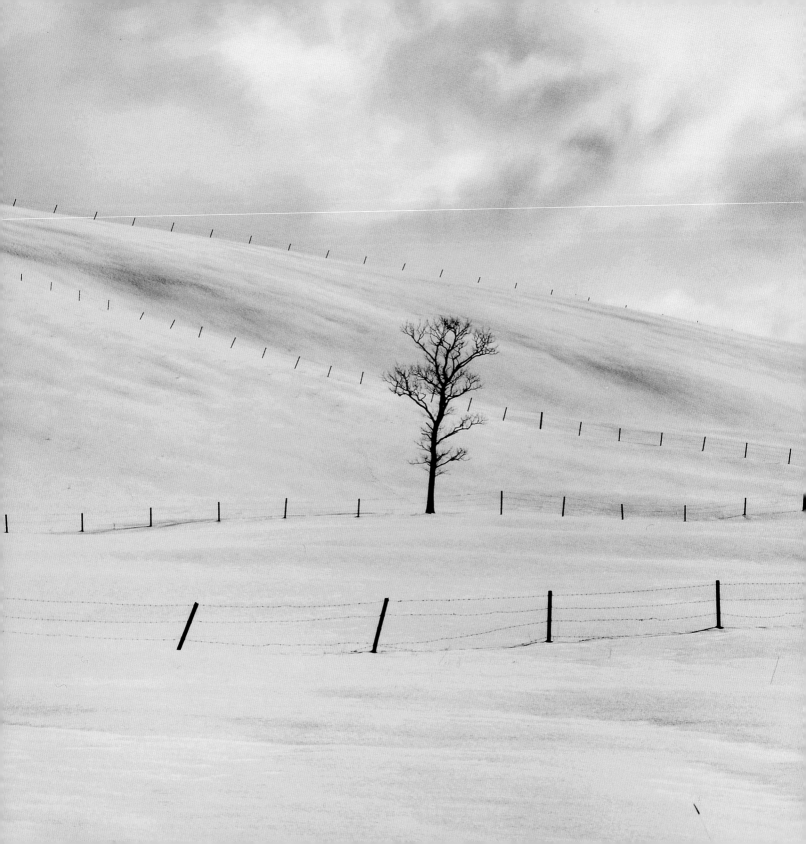

MICHAEL KENNA, "FROZEN LANDSCAPE, TESHIKAGA, HOKKAIDO, JAPAN," 2002
HIROSHI SUGIMOTO, "BODEN SEA, UTTWIL," GELATIN SILVER PRINT, 1993

MINIMALISM BECAME FASHIONABLE IN THE 1960S, BUT LIKE ALL ABSTRACT ART IT ORIGINATED IN THE EXTERNAL WORLD.
KENNA'S LANDSCAPE COMBINES JAPANESE AESTHETICISM'S DISTILLED LYRICISM WITH A HINT OF WESTERN CONCEPTUALISM.
THE SEASCAPES SUGIMOTO HAS CREATED FOR MORE THAN 20 YEARS REDUCE NATURE TO ITS ORIGINS: HEAVEN AND EARTH.

SOPHY RICKETT, "POPLAR PLANTATION, DUNDEE 3 (DETAIL)," 2001
CHRISTOPHER BURKETT, "PINK AND WHITE DOGWOODS," 1991

"THE PLANTING OF A TREE, ESPECIALLY ONE OF THE LONG-LIVED HARDWOOD TREES, IS A GIFT WHICH YOU CAN
MAKE TO POSTERITY AT ALMOST NO COST AND WITH ALMOST NO TROUBLE, AND IF THE TREE TAKES ROOT
IT WILL FAR OUTLIVE THE VISIBLE EFFECT OF ANY OF YOUR OTHER ACTIONS, GOOD OR EVIL." —GEORGE ORWELL

IN ILKKA HALSO'S COOLLY IRONIC PHOTOS CUM INSTALLATIONS,
REPAIRING THE DAMAGE MAN HAS DONE TO NATURE REQUIRES A HEFTY
DOSE OF TECHNOLOGY, WHICH HELPED CAUSE THE ORIGINAL DAMAGE.

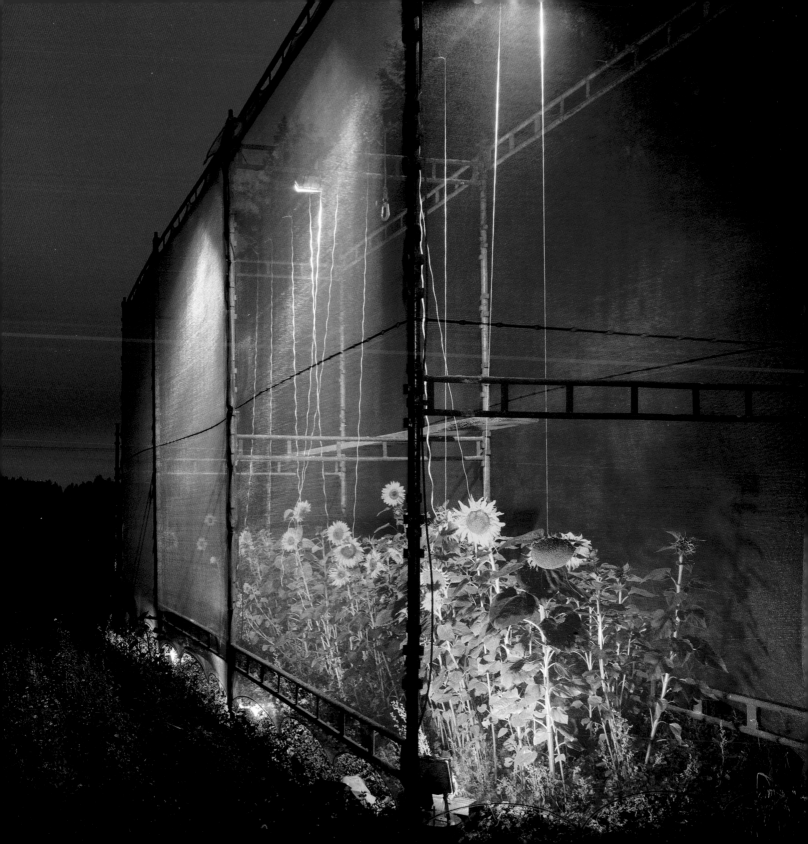

SEEN FROM A CAMERA ATTACHED TO A KITE, THE COAST OF DE RUIJTER'S NATIVE HOLLAND LOOKS LIKE FRAYED
SHAG CARPET BORDERING AN IMPRESSIONIST SKY SCENE. THE DUTCH COAST AND THE HORIZON ARE JUST LINES IN
ELGER ESSER'S MINIMALISTIC PHOTO, WHICH EMPHASIZES THE REGION'S PELLUCID LIGHT AND FLATNESS.

RICHARD MISRACH, "ROAD BLOCKADE, PYRAMIDS," 1989

A TRITE SUBJECT REVIVED BY MISRACH'S UNCONVENTIONAL APPROACH. THE PYRAMIDS ARE
AWE-INSPIRING AND BEAUTIFUL, BUT SEEN WITH THE PAVED ROAD SNAKING TOWARD THEM,
THEY APPEAR DIMINISHED AND FRAGILE. THE MYSTERIOUS BLOCKADE SEEMS TO SYMBOLIZE
THE BREAK BETWEEN TRADITIONAL AND CONTEMPORARY LANDSCAPE PHOTOGRAPHS.

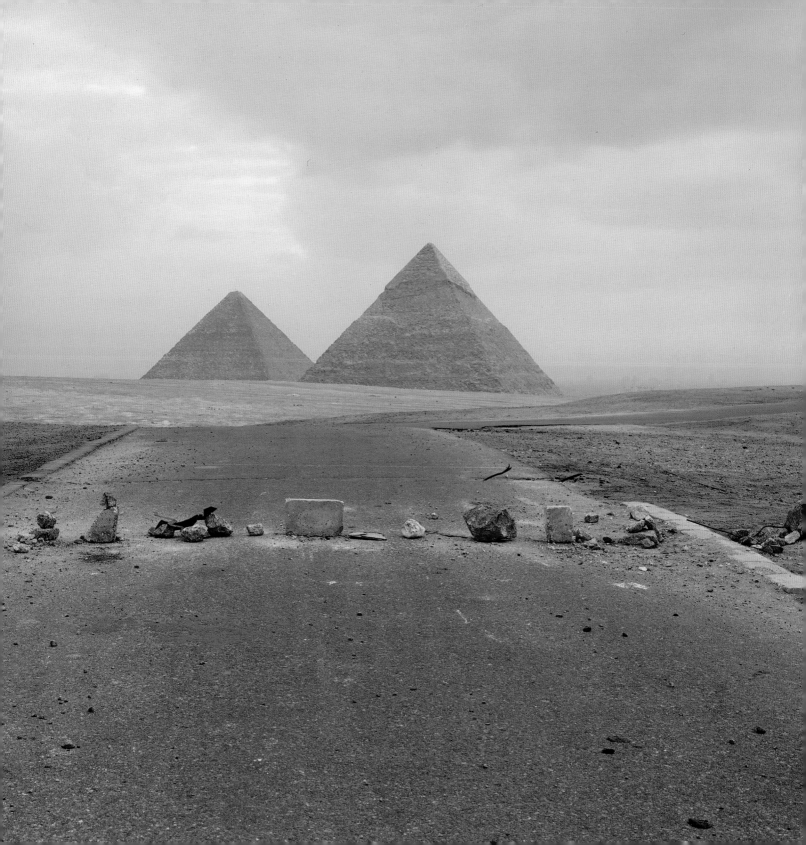

AXEL HÜTTE, "HANA, MAUI," 2001

WITH NONE OF THE ELEMENTS TRADITIONALLY FOUND IN A
LANDSCAPE PICTURE—NO HORIZON, NO OMNISCIENT POINT OF
VIEW, NO VISTA, NO EARTH OR SKY—HÜTTE'S PHOTOGRAPH
LOOKS LIKE THE QUINTESSENCE OF PURE NATURE. THE DEEP
SHADOWS, HOWEVER, SUGGEST THAT EVEN
PARADISE HAS A DARK SIDE.

STEPHEN LAWSON, "THE YEAR OF THE DROUGHT"

TIME AND PLACE SEEM ELONGATED IN LAWSON'S COLLAGE-LIKE PHOTOGRAPH OF THE VIRGINIA COUNTRYSIDE.
EXPOSING NARROW SLICES OF FILM AT SPECIFIC TIME INTERVALS OVER THE COURSE OF A YEAR AND SHIFTING THE
CAMERA'S ANGLE EACH TIME CREATED A FRACTURED LOOK. BUT THE LANDSCAPE IS SEAMLESS AND HAS THE
IDIOSYNCRATIC RESONANCE OF ONE OF PAULUS POTTER'S PAINTINGS OF 17TH-CENTURY DUTCH PASTURES.

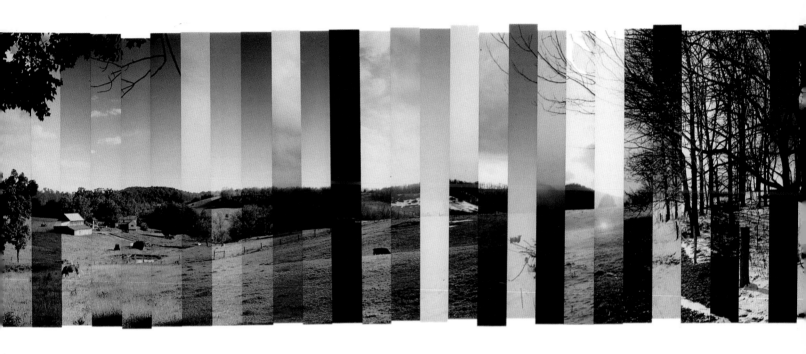

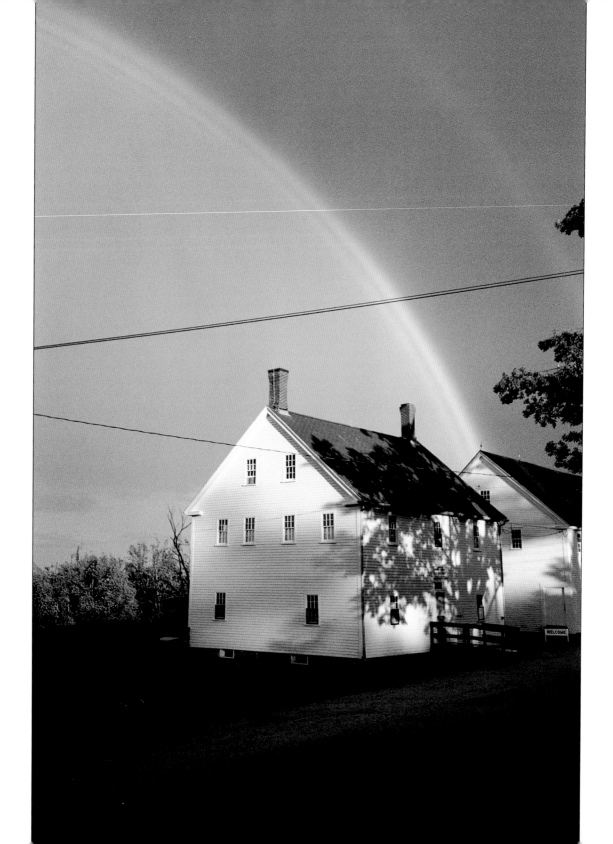

JUDY GARLAND MEETS MOTHER ANN LEE, THE SHAKERS' FOUNDER, SOMEWHERE OVER THE DOUBLE RAINBOW IN TILLMANS'S KITSCHY, INSIDIOUSLY CONCEPTUAL PHOTO OF A SHAKER COMMUNITY, SEXLESS UTOPIA FRESH AND ALLURING AFTER A SUMMER SHOWER. LIKE THE SHAKERS, LANDSCAPE PHOTOGRAPHY OFTEN SEEMS TO TRY TO PERFECT THE WORLD RATHER THAN ACCEPT ITS MIRACULOUS IMPERFECTION.

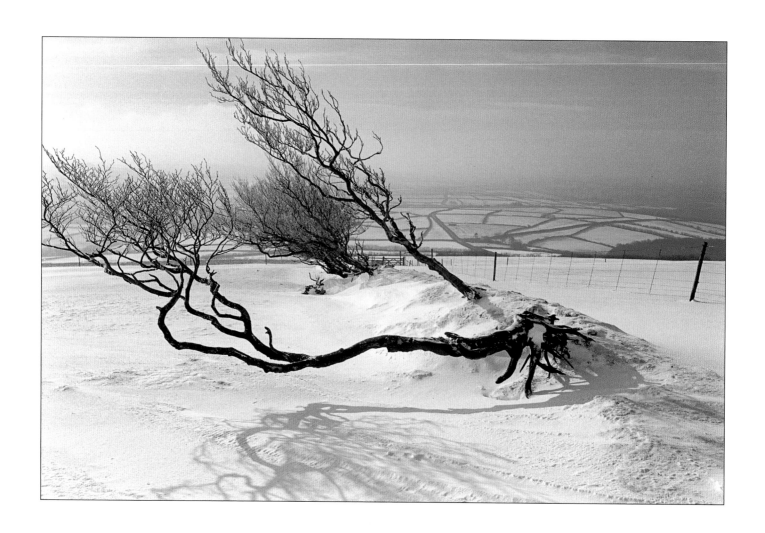

TIMES PAST, TIMES TO COME

WHAT HAPPENED JUST BEFORE THE UNIVERSE WAS CREATED?

Scientists, philosophers, artists, and everyday people have pondered that question for ages and come up with scenarios but no consensus. Regarding the moment of creation, however, there is general agreement that a sudden emanation of light was involved, a big bang, or the biblical God saying, "'Let there be light'; and there was light."

And before the flash, perhaps, two words: Say cheese.

The big bang as flash photo assumes the pre-creation existence of time, photography, a photographer, a subject, and dairy products, debatable assumptions all. But the presence at creation of art's fundamental components—light, time, and matter—is indisputable. There is also no quarrel about our miraculous ability to perceive these things in the external world through sight. As the Roman poet Lucretius wrote in 50 B.C. in his epic "On the Nature of Things": "Know then: from surfaces forever flow / these films of things, fine-textured, finely shaped. / Thus in a flash are many images formed, / And we may rightly style them instant-born."

Photographs, from those of Niepce and Talbot to the latest digital scans, are indeed born of an instant when

JAMES RAVILIOUS, "LOOKING SOUTH-WEST FROM FIVE BARROWS UNDER SNOW, EXMOOR, ENGLAND," 1986
THE LATE JAMES RAVILIOUS EXPLORED IN LOVING DETAIL A SMALL CORNER OF SOUTHWESTERN ENGLAND, FINDING THE VISUAL POETRY IN A WINTER'S DAY. HIS BODY OF WORK CELEBRATES THE CYCLICAL CHARACTER OF HUMAN EXISTENCE, THE FLOW OF TIME, AND THE PLANET'S SLOW BUT UNSTOPPABLE CHANGING, ALL MIRRORED IN THE PEOPLE AND LOCALES OF NORTH DEVON.

a finger pushes a button, selecting and preserving an image. Yet, given human life's brevity and the vast, expanding universe surrounding us, any depiction of landscape can seem as ephemeral as a prairie sunset.

Still, we do it. Human beings have been investigating the origin of this urge to depict since ancient times, with little progress. To find the art impulse's source means answering profound and still open questions about human consciousness: What is it, why do we have it, what is its ecological function? What enables us to experience colors and forms? How is it that we came to exist in this ever changing picture born in a flash, this singular *Gesamtkunstwerk?*

No human knows. In the end, making landscape pictures from creation's raw materials and imagery may be as close as we come to answers. A photograph of a grain of sand can evoke a beach, an ocean, waves shimmering in the sun or dulled to pig iron by clouds moving inland, where their rain refuels the life cycle. No portrait or still life can do that. Landscape photographs distill and communicate these wonders of the world around us, informing our sense of time and place and what it is to be alive. They do so in manifold ways and for individual and collective purposes, some crass, some venal, some noble.

Crassness and venality are human characteristics to which art is not immune. The world is awash with bil-lions of photos. Some are boring landscapes made by famous artists whose works are drooled over by critics and sold for large sums of money. Art's upper echelon is small, cliquish, Manhattan-centric, and inherently conservative. Latter-day Baudelaires shun new, experimental, photographic art as vigorously as their forebear did.

What saves landscape photography are the photos. At its best, the art transcends money and power and communicates on the primal, visual level that preceded language, stimulating our eyes, brains, and souls. The mind, as Aristotle said, never thinks without an image.

How we make images keeps changing. Traditional film-based technology is being replaced by digital technology. At some point in the not-too-distant future, you'll be able to take a high-definition, full-color landscape picture with your handheld media center, turn it into a Stieglitzian black-and-white, and transmit it to a lab that will print it at the size you desire, frame it, and deliver it.

Who needs Ansel Adams's zone printing system when there is Adobe® Photoshop®? Traditional photography won't disappear. The magic of the emulsion is too enchanting, and the combination of brilliant seeing and virtuoso printing by artists such as Sally Mann will always be compelling. But fewer people will do it. It will be to photography what opera is to music, a niche form playing to cognoscenti.

Traditionalists decry digital photography, claiming it destroys what they see as the photographic image's inherent objectivity, its verisimilitude. That view ignores the fact that photographs have always been manipulated. Digital technology is just another tool in the box.

Old or new, photographic technology will keep building the superstructure of the art William Henry Fox Talbot commenced. And landscape photography will remain the supreme test of photographers. It is an inexhaustible subject because the Earth, like the universe, is a finite space yet has no boundaries. As Stephen Hawking wrote in *A Brief History of Time,* "If one keeps traveling in a certain direction on the surface of the Earth, one never comes up against an impassable barrier or falls over the edge, but eventually comes back to where one started." Many of us return to the same places over and over. Even if they look unaltered, time has passed, things have changed. We see differently.

The late James Ravilious spent more than 20 years of his life photographing the people and countryside of North Devon. His black-and-white photographs, such as "Looking south-west from Five Barrows under snow, Exmoor, England," combine modernism's lyrical tonalities and frame-filling composition with a ravishing honesty. Beauty and ugliness are inextricably entwined in Ravilious's pictures. The magic of a tree's shadow on a snowy, hazy winter's day is harvested, not concocted. We see the fences and fields and tire tracks. Ravilious took the scene for what it was, a commonplace miracle, requiring no idealization.

A similarly direct approach can be seen in Jari Silomäki's "Weather Diary" series of photographs. Since 2000, Silomäki has gone out every day, taken a landscape photo, and jotted down in a notebook whatever is on his mind. The idea behind pictures such as "Parkano the day that Germany apologized for its treatment of Marlene Dietrich" is to show how his personal experience of landscape and weather intersected with knowledge of the wider world. "Over the years I think we'll see patterns develop," he says. "For example, something like the World Trade Center attack is likely to recur. But through it all the landscape and the weather will remain."

Those elements take on mysterious, existential weight in Scott Peterman's photographs of ice-fishing shacks on Maine lakes. The shacks bring to mind Bernd and Hilla Becher's anonymous sculptures. But by shooting them in color, in murky light and from a distance, Peterman puts them in a broad, rich narrative context. They seem like homemade spacecraft that have landed in a beautiful but harsh environment, where they serve as a source of warmth, shelter, and, if the fish are biting, food.

William Christenberry began taking color photographs of Hale County, Alabama, where he grew up, as a reference for his paintings. The photos quickly took on

a life of their own as an eloquent visual narrative of the effects of time's passage on the place Christenberry, who resides in Washington, D.C., still considers home. There is nothing sweet or sentimental about his Alabama. The beauty and the ugliness of the land and the buildings are plain and powerful, as in his three photos of the "Palmist Building," at Havanna Junction, taken from 1980 through 1988. In summer, the building that once housed a palm reader is nearly hidden by vegetation. A year later, its weathered presence seems to prop up the bare limbs of the chinaberry tree. When Christenberry returned in 1988, the building, a part of his personal vision of home, was gone, its existence and image relegated to memory and an elegiac photograph.

Time and nature seem to be in corrosive alliance in Timothy Hearsum's panoramic "Route 25—Erosion Control, Near King City, California." The cars full of flood detritus look as if they were part of some invasion force destroyed as it crossed the river. In the background, the stream gnaws the base of the runoff-scarred cliffs, and dark clouds imply another deluge is on the way. The verdant hills and old, silvery oaks provide a sense of growth and renewal, ameliorating the sense of time and nature as inexorably destructive forces.

Literally and metaphorically, man's hand lies heavily on the Rhine River as it flows through Germany. The river has inspired poems, songs, and myths since the Middle Ages and been depicted countless times and ways. In everyday life, it is constantly churned by barges carrying material to and from the industrial plants that grace its channelized banks from the Dutch coast to Switzerland. Busy promenades and bike paths parallel the stream. Hardly promising territory for creating a landscape photograph that explores the traditional notion of the sublime from a thoroughly contemporary viewpoint.

Yet Andreas Gursky's "Rhein" does. Using the computer, he eliminated nearly all traces of human activity, leaving a sublimely beautiful series of horizontal color fields. Depending upon what subtle detail seizes the eye, the spatial relationships between the strips of green and gray constantly shift, making the picture seem flat one moment and improbably deep the next. A tiny set of concrete steps on the far shore could be the stairway to heaven or the path to some Gasthaus that Gursky digitally erased in this seminal demonstration of the computer's power to shape landscape photography.

That power is critical to Colby Caldwell's photographs, such as "how to survive your own death (3)" and "inevitability of a recurring conversation." The images were originally filmed as a Super 8 movie, which he converted to video, played on a television, photographed with a 35mm camera, and then digitally manipulated. The scene depicted is an open field and a distant line of

trees, seen from a train. Caldwell's process breaks it into pixels and blotchy splashes of radioactive color as if it had survived some digital nuclear holocaust. In "inevitability…" he uses the computer to bore into the electronic composition of the picture and extract the visual DNA, the blobs of color that form the image. Taken together the photos are an allegory for how memory functions, for the bright patterns of neural activity representing a place and objects that somehow remain in our brains long after the train ride ends.

I wasn't thinking about landscape as an abstraction or DNA when I photographed the sunset. Those qualities came to mind a couple of years later when I returned home to help my parents pack up and move away. Flying in, I stared down on the sea of geometry.

Most of Illinois isn't prairie anymore, although we call it that. Tallgrass prairie covered some 60 percent of the state's approximately 22 million acres before European settlers came in the early 19th century. The vegetation was so tall and dense one often couldn't see the horizon from atop a wagon. The flat, open space I love can be traced to John Deere, who invented the self-scouring steel plow in Illinois in 1837. Now, only about 2,000 acres of real prairie remain.

In the satellite photo of Decatur on a winter's day, the city looks like a blotch amid a mosaic of fields, the patch of prairie I shot a mere squiggle by the river. But the dis-

tant perspective doesn't diminish my sunset pictures; it unites the place, the people, and the time, dressed in my myths and memories, with the immense, boundless sky.

The impalpable and imaginary, the addition of something of a Southern woman's soul, is what makes Sally Mann's "Untitled, 1998, #38," from her *Deep South* series, an affecting piece of art. The flat land is seen as from a car. Mann's hand tinting makes her print look aged. But this landscape is a timeless place full of empiness and human presence, beauty and banality, life and death. The road leading us, perhaps, toward Leo Tolstoy's "eternally remote state of perfection" dissolves in the distant, blurry horizon. Portent suffuses the picture, as if something is about to happen, like a flash turning nothingness to the unfathomable oneness of the universe or the porch light going out on a dairy farm just this side of paradise.

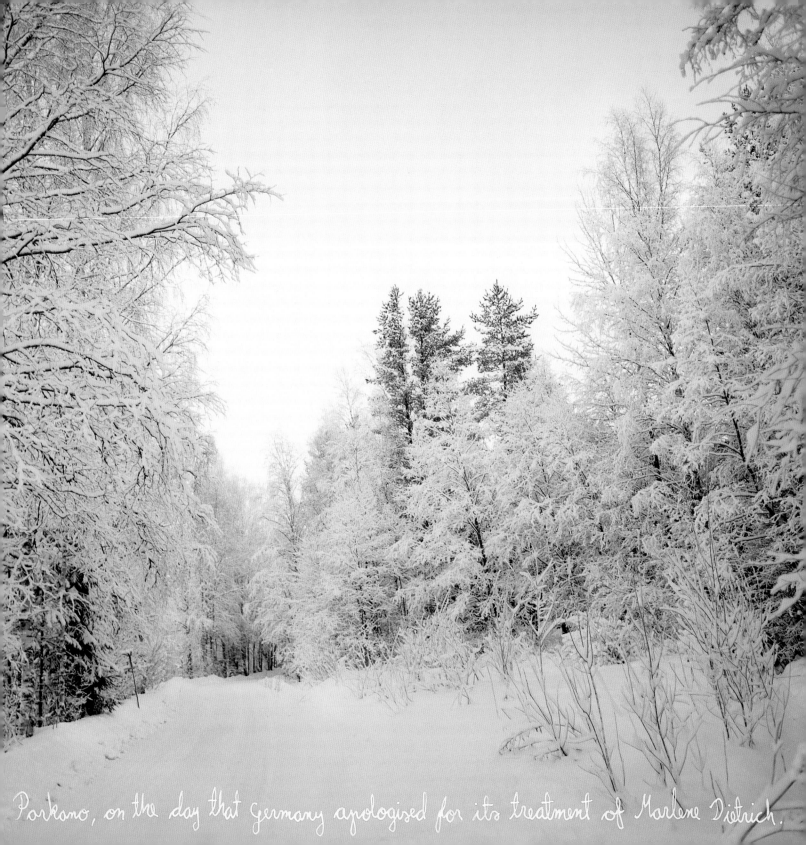

Porkano, on the day that Germany apologised for its treatment of Marlene Dietrich.

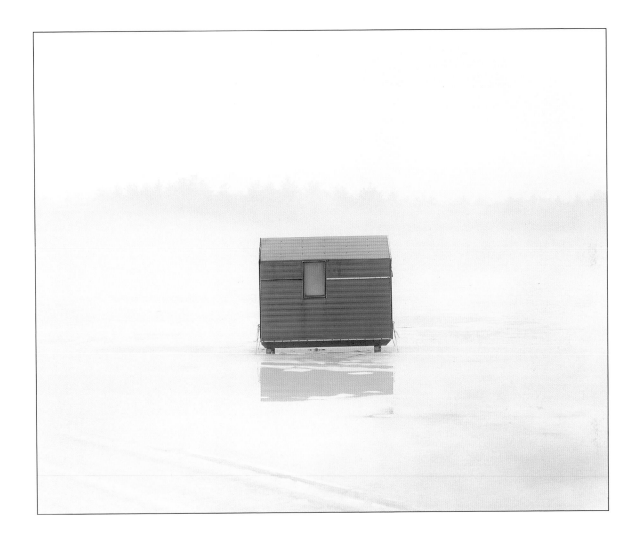

JARI SILOMÄKI SAYS HIS WEATHER DIARY "BEGAN FROM THE CONTEXT OF A PERSON CARRYING IDEAS AND INFORMATION FROM AROUND THE WORLD INTO THEIR PERSONAL SPACE." SCOTT PETERMAN PHOTOGRAPHS ICE-FISHING SHACKS IN MAINE BECAUSE THEY "ILLUSTRATE A PRIMAL NARRATIVE WHOSE ELEMENTS ARE SHELTER, FOOD, WARMTH AND AN ONGOING BATTLE AGAINST THE CAPRICES OF NATURE."

WILLIAM CHRISTENBERRY, "PALMIST BUILDING (SUMMER), HAVANNA JUNCTION, ALABAMA," 1980

"PALMIST BUILDING (WINTER), HAVANNA JUNCTION, ALABAMA," 1981

"SITE OF PALMIST BUILDING, HAVANNA JUNCTION, ALABAMA," 1988

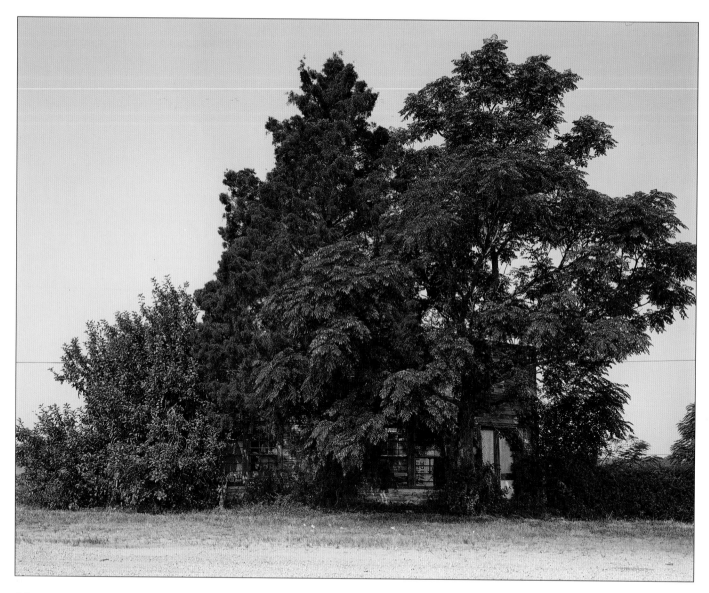

"I'VE ALWAYS THOUGHT OF MY WORK AS LANDSCAPE. WHAT INTERESTS ME THE MOST IS HOW TIME AND PEOPLE CHANGE IT," CHRISTENBERRY SAYS. "I CAN ONLY MAKE PICTURES WHEN I GO HOME TO ALABAMA. I CAN GO ELSEWHERE AND, FORMALLY, THEY'RE FINE. I CAN PUT TOGETHER A PICTURE. BUT THEY DON'T RESONATE, AT LEAST FOR ME."

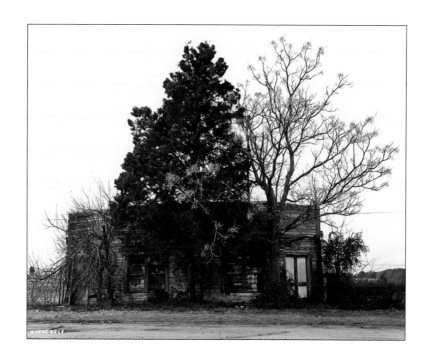

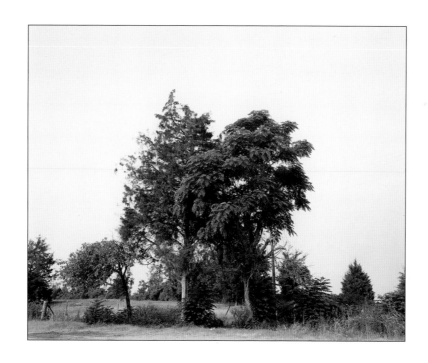

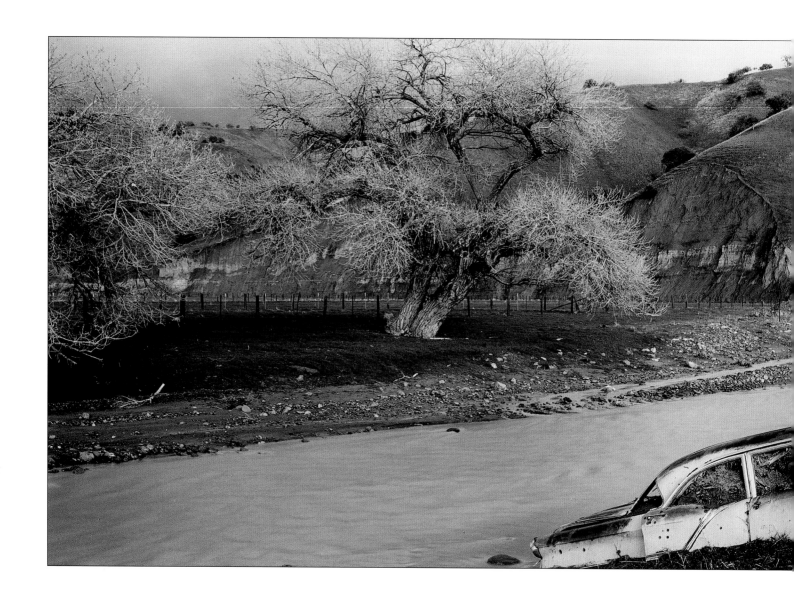

A PANORAMIC CAMERA LETS TIMOTHY HEARSUM CAPTURE A BROAD PERSPECTIVE SIMILAR TO HUMAN
PERIPHERAL VISION. HIS PHOTO OF THE RIVER, A METAPHOR FOR TIME ERODING THE LAND, SLOWED ONLY
BY THE RUSTING BODIES OF OLD CARS, COMBINES IRONY, EARNESTNESS, AND NATURE'S STOLID MAJESTY.

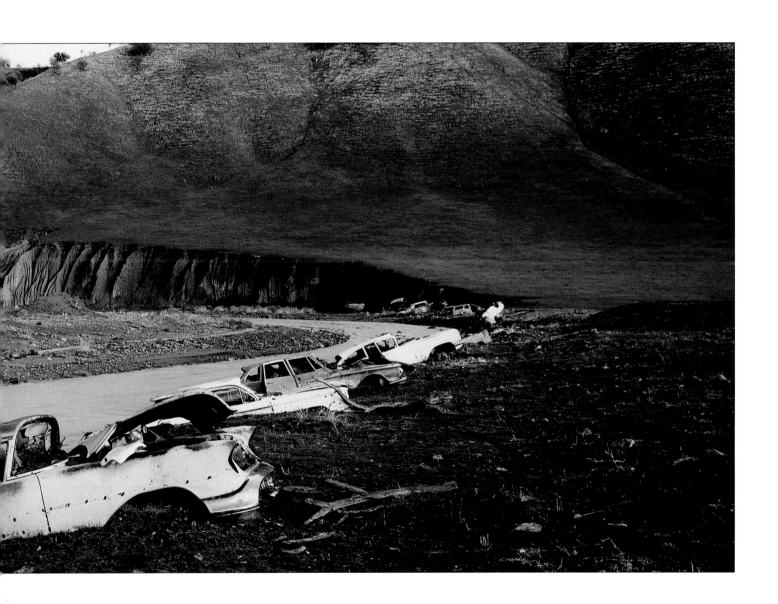

ANDREAS GURSKY, "RHEIN," 1996

THE RHINE FLOWING THROUGH GURSKY'S NATIVE GERMANY LOOKS LIKE
CRINKLY LEAD FOIL BETWEEN ITS STRAIGHTENED, MANICURED BANKS. THE
ARTIST USED A COMPUTER TO ELIMINATE OVERT TRACES OF MAN, TURNING
THE RIVER AND ONE OF EUROPE'S MOST DENSELY SETTLED REGIONS INTO
PSEUDO-PRIMAL OR POSTAPOCALYPTIC FIELDS OF COLOR, TEXTURE, AND LIGHT.

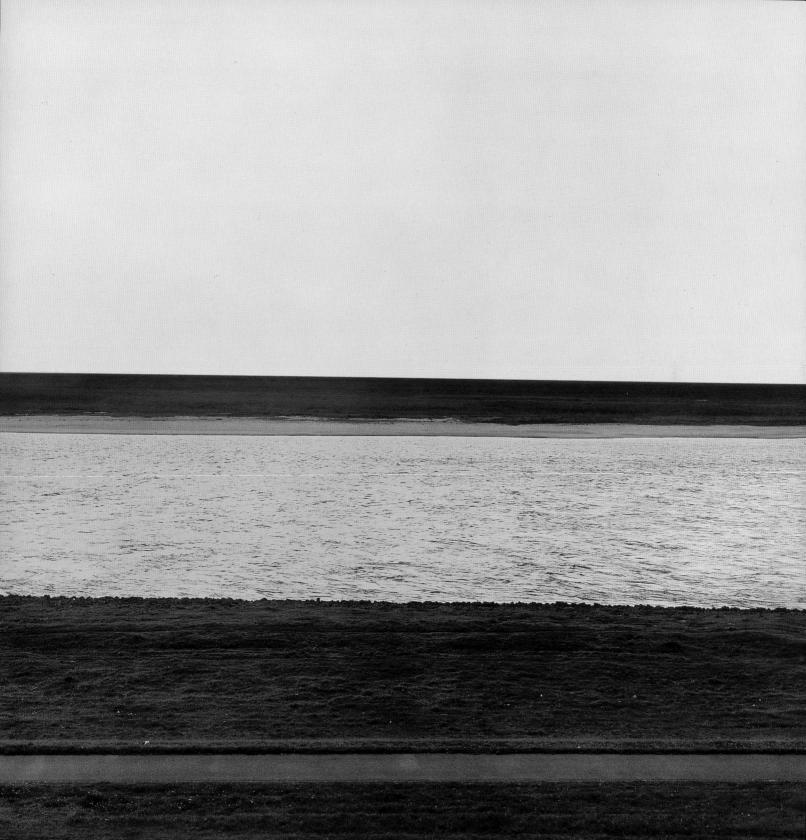

COLBY CALDWELL, "HOW TO SURVIVE YOUR OWN DEATH"(3), 2001
COLBY CALDWELL, "INEVITABILITY OF A RECURRING CONVERSATION," 2001

MOTHER NATURE BECOMES ELECTRIC LADYLAND IN CALDWELL'S PHOTOGRAPH. IT ORIGINATED AS A
SUPER 8 FILM, WHICH HE CONVERTED TO VIDEO, PLAYED ON A TELEVISION, PHOTOGRAPHED WITH A
35MM CAMERA, AND DIGITALLY MANIPULATED. THE PIET MONDRIANESQUE ABSTRACTION IS A DETAIL,
CULLED AND AMPLIFIED FROM THE ORIGINAL IMAGE, LIKE THE DNA OF LANDSCAPE PHOTOGRAPHY.

NASA, "DECATUR, ILLINOIS, U.S.A. WINTER 1995-1996"

WHAT COLBY CALDWELL FOUND DEEP INSIDE THE PHOTO-REPRODUCTIVE PROCESS,
THE NATIONAL AERONAUTICS AND SPACE ADMINISTRATION FOUND ON A WINTER'S DAY IN
DECATUR, ILLINOIS: LANDSCAPE AS THE CONVERGENCE OF TIME, PLACE, AND PEOPLE.

SALLY MANN'S LANDSCAPES ARE A COMPLEX, HIGHLY PERSONAL BALANCING OF SENSORY EXPERIENCE AND REASON, HEART AND MIND, EYE AND GUT. HER PICTURES ARE FILLED WITH AMBIGUOUS PORTENT AND A SENSE OF JOURNEYING. THE HORIZON IS BLURRED, THE LIGHT STRANGE BUT FAMILIAR. THE VIEWER CAN'T TELL WHETHER IT IS DUSK OR DAWN. BUT SOME EVENT, WHETHER GOOD OR BAD, IS ALWAYS IMMINENT, UNAVOIDABLE, AND DEAD AHEAD.

ACKNOWLEDGEMENTS

For their support and assistance in making this book possible, I'd like to thank my wife, Julia, my son, Thomas, and all the artists, galleries, museums, and organizations named and quoted in these pages. Special thanks go to my research assistants, Edith Tyler Emerson and Natasha Scripture, and Bill Bonner, as well as to Sarah Greenough, Paul Roth, the National Gallery of Art Library, Marion Belanger, Kathleen Ewing, George Hemphill, Nailya Alexander, Jo Tartt, Sally Troyer, Milton Esterow, Asko Mäkelä, Paula Toppila, Timothy Persons, the Finnish Ministry for Foreign Affairs, FRAME Finnish Fund for Art Exchange, and Stewart Drescher and Anne Jackley. I'm especially grateful to National Geographic Books and to Leah Bendavid-Val for backing and guiding this project and generously sharing her wisdom, and to my editor, Becky Lescaze, and Peggy Archambault, who designed the book.

LANDSCAPE
FERDINAND PROTZMAN

Published by the National Geographic Society

John M. Fahey, Jr., *President and Chief Executive Officer*

Gilbert M. Grosvenor, *Chairman of the Board*

Nina D. Hoffman, *Executive Vice President*

Prepared by the Book Division

Kevin Mulroy, *Vice President and Editor-in-Chief*

Marianne R. Koszorus, *Design Director*

Leah Bendavid-Val, *Editorial Director, Insight Photography Books*

Staff for this Book

Leah Bendavid-Val, *Editor*

Rebecca Lescaze, *Text Editor*

Peggy Archambault, *Art Director*

R. Gary Colbert, *Production Director*

John T. Dunn, *Technical Director, Manufacturing*

Richard S. Wain, *Production Project Manager*

Natasha Scripture, *Editorial Assistant*

Sharon K. Berry, *Illustrations Specialist*

Library of Congress Cataloging-in-Publication Data

Protzman, Ferdinand.
 Landscape : photographs of time and place / Ferdinand Protzman.
 p. cm.
 ISBN 0-7922-6166-6
 1. Landscape photography. I. Title.

TR660.5.P76 2003 2003054036

One of the world's largest nonprofit scientific and educational organizations, the National Geographic Society was founded in 1888 "for the increase and diffusion of geographic knowledge." Fulfilling this mission, the Society educates and inspires millions every day through its magazines, books, television programs, videos, maps and atlases, research grants, the National Geographic Bee, teacher workshops, and innovative class-room materials. The Society is supported through membership dues, charitable gifts, and income from the sale of its educational products. This support is vital to National Geographic's mission to increase global understanding and promote conservation of our planet through exploration, research, and education.

For more information, please call 1-800-NGS LINE (647-5463) or write to the following address:

National Geographic Society
1145 17th Street N.W.
Washington, D.C. 20036-4688 U.S.A.

Visit the Society's Web site at www.nationalgeographic.com.